IMAGES
of America

BIG SPRING
REVISITED

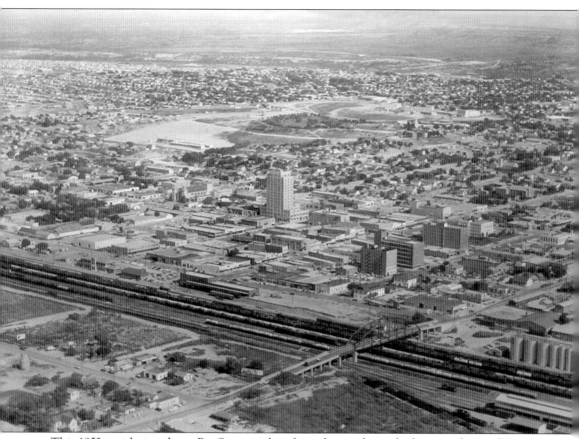

This 1952 aerial view shows Big Spring, taken from the northwest looking southwest. (Heritage Museum of Big Spring.)

ON THE COVER: In the 1930s, the Fisher family was entertaining relatives from Terra Haute, Indiana, on top of the Scenic Mountain. In 1885, Albert Fisher was born behind The Fisher Mercantile in a tent home. Albert (left) and his wife, Edith (pictured on back of cover), had two sons, Albert Jr. and Edward Bernard Fisher (pictured on right). (Ed Fisher Collection, Heritage Museum.)

IMAGES
of America

BIG SPRING REVISITED

Tammy Burrow Schrecengost

ARCADIA
PUBLISHING

Published by Arcadia Publishing
Charleston SC, Chicago IL, Portsmouth NH, San Francisco CA

Printed in the United States of America

Library of Congress Control Number: 2010923669

For all general information contact Arcadia Publishing at:
Telephone 843-853-2070
Fax 843-853-0044
E-mail sales@arcadiapublishing.com
For customer service and orders:
Toll-Free 1-888-313-2665

Visit us on the Internet at www.arcadiapublishing.com

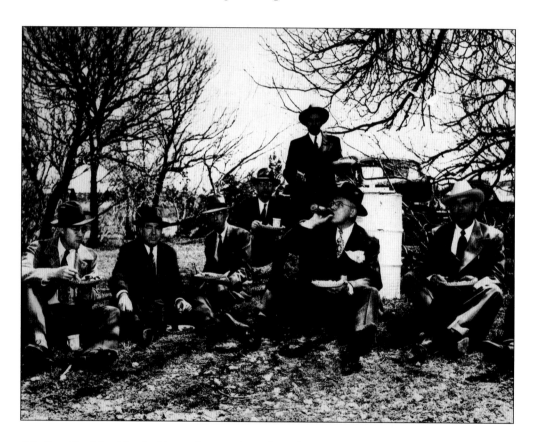

*To Joe Pickle (far left), a devoted and dedicated historian who researched
and sifted fact from fiction and truth from legend for over 70 years.*

CONTENTS

ACKNOWLEDGMENTS

I am extremely grateful to the following people who provided photographs, notes, journals, anecdotes, and encouragement: Joe Pickle, Polly Mays, the John Birdwell family, Jean Porter Dmytryk, Patricia McCormick, Jody Nix, Wade Choate, Bill and Lavonne Montgomery, Maydell Rolley, Ed Fisher, John Hutto, Clara Hernandez, Aldan Ryan, L. S. McDowell, Olive Ruth Cowden, Larry Nix, Tot Sullivan and Pearl Bradshaw, Wells Fargo Bank, Nancy Rancy, Wanda Cottingham, the Rhoton family, Harold and Janell Davis, Emma Johnson Hall, Jeannie Knocke, Jimmy Johnson, Adelle Tibbs, Milton Perkins, Clarance Hartfield, Susan Zack Lewis, Tumbleweed Smith, Doyle and Betty Fenn, Emma Doe, Jody Nix, Jim Baum, the Ann Sanders family, Amie Wood and the Heart of West Texas Museum, and Marj Carpenter.

There are many more names of people who had an important impact on Big Spring but are not included in the book due to space limitations. The collection of photographs and information within would not have been possible without the contributions of many dedicated historians and families, past and present. Unless otherwise noted, photographs in this book came from the collection at the Heritage Museum of Big Spring. My deepest gratitude goes to my museum colleague Nancy Raney who has graciously assisted and led me and offered words of encouragement during these past 14 years. A special gratitude goes to Cheryl Joy and Janet Abner for their hours of editing and to the dedicated Heritage Museum Board of Directors: Jane Jones, Katie Cathey, Robert H. Moore III, Janell Davis, Katie Grimes, Quail Dobbs, and Mary Lane Reynolds.

A very heartfelt thank you goes to the *Big Spring Herald*. Big Spring's history may have been lost had it not been for the dedicated writers, photographers, and staff who, throughout the years, interviewed, recorded, and preserved local and world history.

I dedicate this book to my five grandchildren: Mckenzie Schrecengost, Austin Lasater, Cayson and Cayden Schrecengost, Caston Williamson, and my "special" grandchildren: Samantha and Gracie Raney.

Finally, I dedicate this book to the memory of John, Annabel, Lillian, Annabel II, Dan, Banton, Maydell, and Johnanna Birdwell.

INTRODUCTION

At the time of the 1880 census, there were 25 Texas Rangers residing in Howard County along with a few herdsmen and their wives. Rangers were sent ahead of the Texas and Pacific (T&P) Railroad to protect the open frontier from trouble. The Rangers seemed to always find problems wherever they went, as they contended with local disturbances that amounted to miniature wars, bloody feuds, lynch mobs, train robbers, cattle thieves, barbwire fence cutters, killers, and other bad men. As soon as the T&P Railway was established, 15 saloons were promptly built in Big Spring. Trouble brewed continuously, and law and order had to be established quickly.

On March 16, 1881, the first construction train entered Big Spring. In spite of the fact that the tools of construction were crude, progress was rapid. In November 1881, the train rails were completed to El Paso. The roadbed was thrown up hastily to say the least, but the job was done, and train service was in business.

Talk ran up and down the Texas and Pacific rails about a new town developing named Big Spring. Water was scarce in West Texas and to find a flowing spring was a very favorable attribute in a town. In 1883, John Birdwell brought his young bride, Annabel, to Big Spring. He ran the T&P Railroad Hotel while owning the Ranch Saloon. Birdwell served as sheriff of Howard County in 1886 and remained in Big Spring until his death in 1920. He and Annabel raised a loving family and were deeply rooted in the community.

The Earl of Aylesford brought his English manners and charm to town along with his zest for the drink. He spent his ample allowance on several town properties and on entertaining. However, in January 1885, his insatiable appetite for alcohol resulted in his early death. Texas Ranger Jeff Milton's law enforcement exploits made settlement possible for this small West Texas town. Milton confidently gambled with death among the most dangerous men of the West. He was a symbol of his age in a wild and sparsely settled region. At the age of 58, Jeff met and married the love of his life, Mildred Taitt and eventually retired in Arizona.

As Big Spring continued to grow, settlers from other states such as Tennessee, Georgia, and Florida flocked to the frontier. The growth of the railroad and promises of a new start also brought settlers from other countries as well. They came from England, Ireland, China, and Mexico. All these settlers together carved out a life on the West Texas frontier. As the centuries progressed, so did the town. Order was established, permanent buildings were constructed, streets were paved, schools were erected, and water, gas, electric, and phone service was established. The horse and buggy was soon replaced with the automobile, and, in the 1920s, the discovery of oil changed the population and occupations of many Big Spring residents. Cotton became a stronger crop than wheat and milo, and cattle remained the primary livestock in the area. Many famous people passed through the town including Lawrence Welk, Jean Porter, Michael Landon, and Will Rogers. In 1957, Carl Perkins, Jerry Lee Lewis, Johnny Cash, and Elvis Presley performed at the City Auditorium. Texas governor Rick Perry trained at the Webb Air Force Base. The president of the United States, Lyndon B. Johnson, attended the funeral of the father of Joe and

Congressman Jake Pickle in 1970. Big Spring's first federal prison was also host to other famous men such as Billie Sol Estes and Rexie Cauble. On life in Big Spring, pioneer Mittie Barrett told a reporter for the *Big Spring Texas Pantagraph* newspaper, "There have been many thorns, but too there have been the roses." Hopefully the images depicting Big Spring's colorful past might inspire efforts to preserve the past as well as expand and preserve the future of this once-small West Texas town.

One

JOHN, JEFF, AND THE JUDGE

John Dekalb Birdwell was born October 1, 1848, in Tennessee. Shortly after the Civil War, Birdwell decided it was time to seek his own fortune, and with only the clothes on his back he made his way to Fort Worth, Texas. After working as a hotel clerk and stage agent, he continued to roam farther northwest working as a cowboy, a buffalo hunter, and trading cattle for trail herds. Eventually his hunting expeditions took him around Fort Griffin, Texas. He had a deep hate for the Comanche Indians, as he recalled arriving on a scene of one of their massacres, in which he found a nine-year-old girl hanging from her arms and legs from two trees and split in two. His father had fought in the Battle of Plum Creek, and John wanted to conquer the Comanche and make his mark on the new Texas frontier. In 1879, he enlisted with the Texas Rangers, Company C under Capt. G. W. Arrington. In order to purchase his uniform, he had to borrow $6 from the State of Texas.

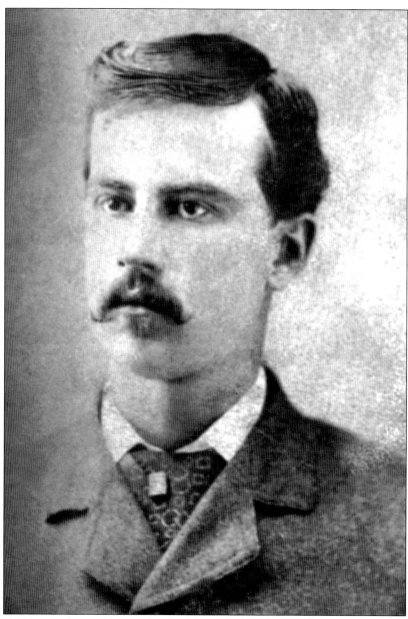

Jeff Davis Milton was born on November 7, 1861, to the governor of Florida, John Milton, and his wife, Caroline. Jeff and his seven sisters enjoyed the finer things in life on the family's 7,000-acre cotton plantation named Sylvania. Towards the end of the Civil War, Jeff's father committed suicide when it became evident that the South would lose. During these uncertain times, Jeff began reading everything he could about Western literature as well as listening to travelers' tales and town talk. These adventures quickly turned him heart and soul toward the Western frontier. At the young age of 16, Jeff set out for the Lone Star state of Texas. He stayed with his sister and brother-in-law and worked at their mercantile in Navasota, Texas. He then worked his way (as a cowboy) to Fort Griffin. While fulfilling part of his dreams, he was drawn to the life of a Texas Ranger. On July 27, 1880, Jeff grew a "manly" mustache and joined the Rangers just a few months shy of the required age of 21.

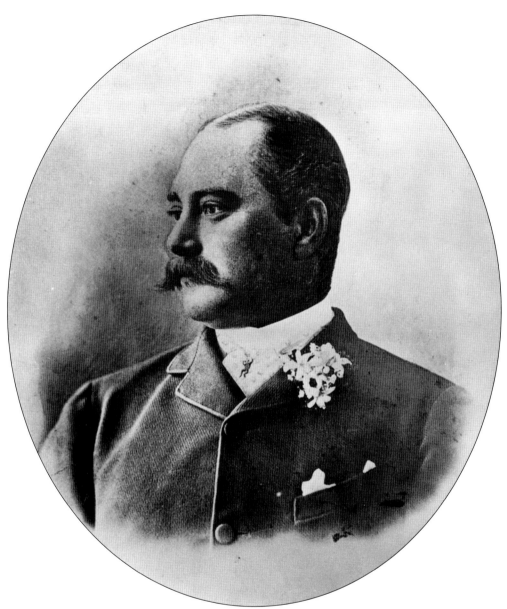

The Earl of Aylesford, Henneage Finch, was born February 21, 1849, in Packington Hall, the 100-room mansion and ancestral home of the Aylesfords. The estate was surrounded by 16,000 acres of grounds in Warwickshire, England. The earl was known as a handsome and most-charming gentleman who graduated with honors from Eton and later Oxford University. On May 8, 1870, the earl married the beautiful Edith Williams. Promptly after the wedding, the earl's father, the sixth Duke of Aylesford, passed away, and he succeeded to the title. The couple had two daughters and was the center of social affairs. The earl was close to the Prince of Wales and joined him on an elaborate hunting trip to India. While away, Lady Aylesford informed the earl in a letter that she was leaving him for Lord Charles Blandford. Following a scandalous and public divorce proceeding, the couple was denied a divorce. It was decided that both parties were involved in adulterous behavior. The duke was given a $50,000-a-year allowance, and he left for America on an extended hunting trip.

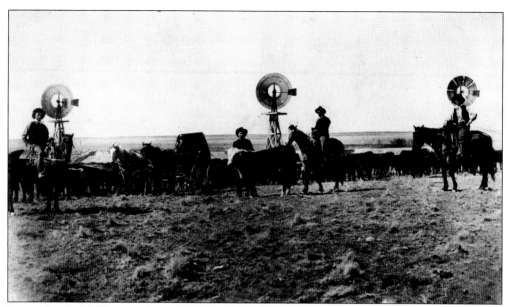

Pictured is the "O" Bar Ranch in 1888. Texas, then half-settled, was rough and ready for adventurous young men, ready to fire the imagination of anyone who loved space above money, adventure above security, and grass above crops. (Kent Morgan Collection.)

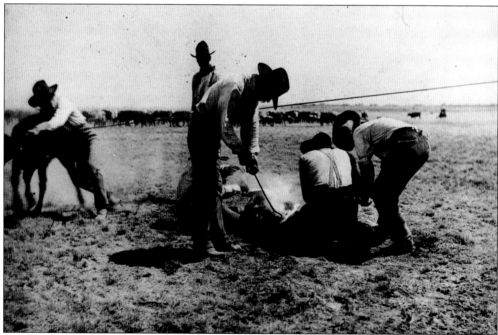

Though it was made legendary in book, song, and campfire tale, the life of the early cowboy was usually less romantic than was depicted in those stories. It was a life of hard, dirty work and long hours. However, it could find its way into the blood of a man until he could imagine nothing else. Shown here is open-range branding in 1884 at the long "S" Slaughter Ranch. (Kent Morgan Collection.)

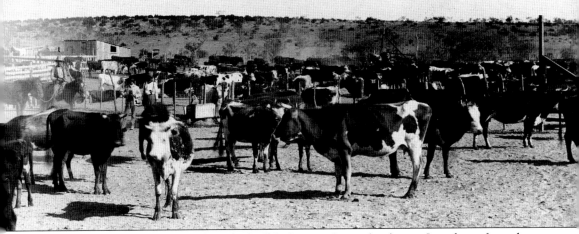

The American Indians depended on the buffalo for a ready supply of meat. In order to force the last of the Comanche to the reservations, it was decided that a mass destruction of the buffalo was necessary. The buffalo hunters migrated west in great numbers. The commercial interest lay in the hide, meat, and bones. Hunting parties consisted of four men—one shooter (serving as captain), two skinners, and one man to cook, stretch hides, and supervise the camp. Each fall, the country was overrun by buffalo from the north as they came south grazing, moving at least 3 miles a day. The buffalo covered the entire territory so that by the spring of the year, when the animals reversed their course and started north, they had eaten up all the grass, causing the cattlemen grief. This photograph of longhorns was taken on the C. L. Alderman Ranch.

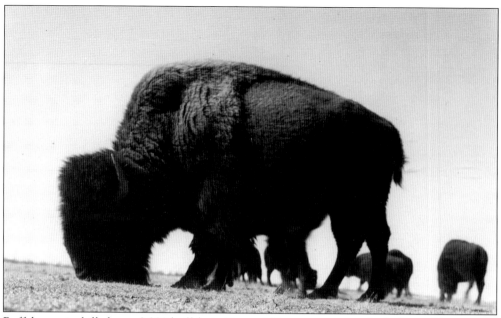

Buffalo parties killed over 3,000 buffalo in Howard County, stripping the hides and leaving the bones to dry in the open prairie. Bones were gathered by the early pioneers and stacked in immense piles along the right-of-way awaiting transport to the eastern market. Some say the stacks along the railroad grew until they seemed a city-block long. (Wade Choate Collection.)

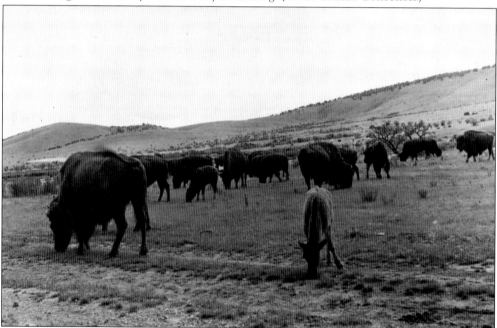

From 1871 to 1874, approximately 4.5 million bison were slaughtered. By the time Col. Charles Goodnight and others moved to save the bison, only around 1,300 remained. The last-seen buffalo was a massive bull, which came through here around the early 1880s. The lone bull continued on his journey to the northwest, moving into the sunset, leaving behind him his memorial—a sea of bleaching bones. (Brennand Collection.)

14

W. T. Roberts (at right) once remarked that the bones lay so thick around the Moss Spring, a person could walk on them without touching the soil. Anxious to have a neighbor, he allowed Englishman Jimmy Killfall permission to pick up bones and stack them. Killfall made over $900 from the sale of his bones. (Wade Choate Collection.)

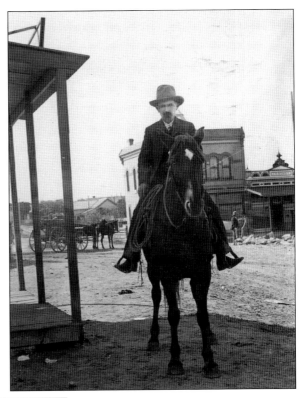

Captain Marsh was an old Confederate War colonel with one arm shot off at the shoulder and the other hand almost gone. In the book, *Gettin' Started*, by Joe Pickle, Jeff Milton said, "He (Captain Marsh) would drink a right smart and scrap a right smart. Give him two drinks and he would spit in a tiger's eye. Shore would!"

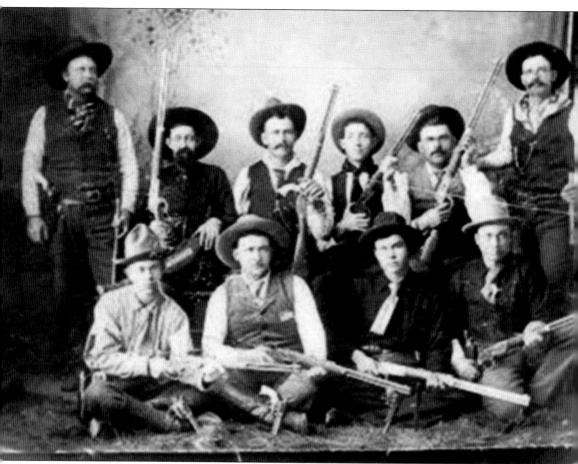

A Ranger had to furnish his equipment: his saddle, ropes, guns, bedding, horses, and clothing. The Texas Rangers always stood out in their broad-brimmed, white hats and the heavy buckled, cartridge-studded belts that carried six-shooters on the hip and high-top boots (almost to the knee) tucked into the pant legs with handmade Texas spurs. Regulations for guns permitted the .44 Winchester carbine, the short-barreled "saddle gun," and the .45 Colt six-shooter. When a recruit joined, he was given 100 shells, and the state furnished him 12 additional rifles and six pistol cartridges monthly. The Texas Rangers were not armed for dramatic effect or for sport. "Bullets were for business."

During the construction of the railroad and the booming cattle industry, everyone involved in the ventures had an abundant supply of money. The stakes in the gambling halls were high, but life was cheap. Jeff Milton saw a young cowboy sitting cross-legged on the edge of a monte table, gambling his life away with Clay Mann (pictured) backing him, his herd as collateral. At last, when he had lost $20,000, Mann told him that was as far as he could go. "You can't let me have any more?" inquired the cowboy. "That's all your cattle are worth," said Mann. The young cowboy pulled his gun, shot himself through the head and fell dead off the table onto the floor, and the game went on. (Bud Tucker collection.)

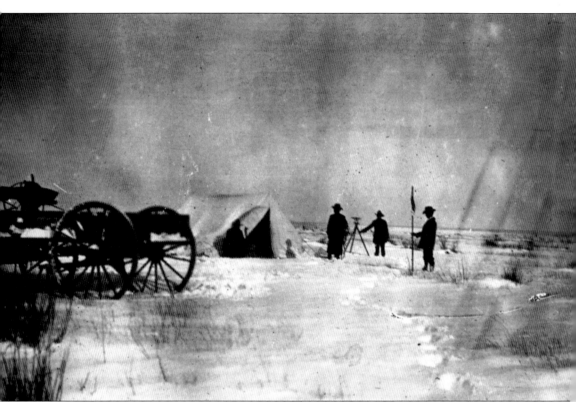

On December 29, 1879, during a blinding blizzard, John Birdwell took part in Company C's decision to pursue the American Indians who had raided the Slaughter Brothers' ranch holdings. Ranger James B. Gibson of Company C led the Rangers after putting together 10-days' worth of rations and supplies. They pushed south past Yellowhouse Canyon (near Lubbock) when mist and freezing rain began to fall. The Rangers continued on 60 miles to Double Lakes and then turned toward Silver Lake and found a pond that they named Ranger Lake. Still pointing westward, they were trapped. One of the Rangers in the company later reported, "One of the worst blizzards I ever saw, with snow piled up to 18 inches. John could not go on any further, he was paralyzed by the cold and his horse gave out. His saddle was changed to an Indian pony, and he was lashed on. Finally, we dropped off a bluff into a canyon, and John was laid in the snow and covered with blankets." The Rangers were able to find a cave, and John soon recovered.

Jeff Milton's speed with a pistol was said to be "uncanny." He received a bullet in his hip when he tried to catch an outlaw. In Milton's report, he penciled in, "He tried to kill me, so I shot him in the forehead, in the nose, and under the chin, and he died first."

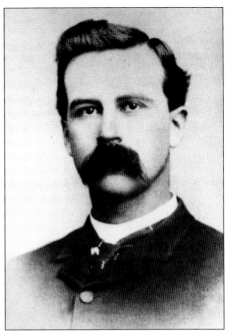

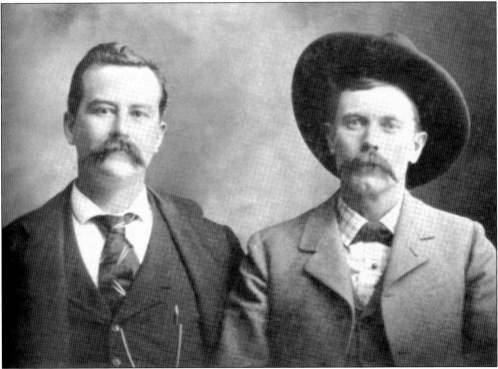

Jeff Milton (pictured left) courageously gambled with death among the most dangerous men of the West. After three years with the Rangers, Jeff left the service and became El Paso's chief of police. He later signed on as deputy U.S. marshal and border patrol as he single-handedly guarded the border from Nogales to the Gulf of California. George Scarborough (pictured on right), a deputy U.S. marshal, and friend joined Milton on the capture of several criminals.

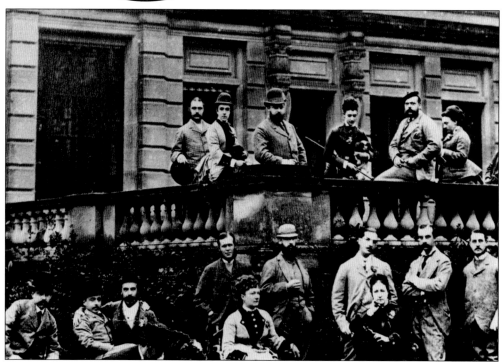

After only six months as a Ranger, John Birdwell was honorably discharged. The usual period of enlistment was a year, and those who lusted for the vigorous life stayed longer. Others would quit, becoming sheriffs of counties they had helped to conquer and settle. John later became sheriff of Big Spring, but first he disassembled his saloon in Fort Griffin and brought it to Colorado City, naming it the Lone Wolf.

In 1881, word spread to Colorado City, Texas, that three railroad cars of English lords were coming. Curious, the entire town turned out in an awed welcome. On a warm summer day in August 1881, the Earl of Aylesford stepped off the train and surveyed the crowd, saying, "I'm looking for a man named John Birdwell." He was sent to the Lone Wolf saloon where Birdwell was proprietor.

Despite the West Texas heat, the earl was fashionably and impeccably attired. Most impressive to all was a shiny black top hat. The earl was an immediate sensation when he made his appearance in the small frontier town. As everyone in the saloon stared in amazement, the magnificently dressed visitor stepped lightly up to the bar and ordered a double whiskey, which was immediately consumed. The man followed this by another "double" in quick succession. There was no doubt about it; the Englishman was a drinking man. After the third stiff drink was downed, the visitor appeared inclined to talk and looking directly at John Birdwell said in a haughty voice, "My good fellow, do you know who I am? I am Heneage Finch, the Earl of Aylesford and seventh member of my illustrious family to enjoy the distinction of the title."

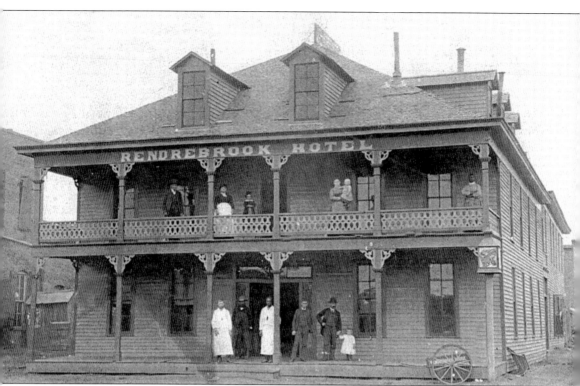

There was no reaction from John Birdwell, who continued to lean against the bar, one boot heel firmly locked on the bar rail. Continuing, the earl embarked on a recitation of his own lineage and threw in an impressive list of prominent friends. Birdwell had kept his peace, saying nothing. Finally he interrupted, saying, "Look here, Earl, all that stuff won't go down here. We'll just call you Judge." John and "Judge" quickly became friends. Jeff Milton recalled seeing the two sitting in the shallow Colorado River, sobering up, with a bottle between them on a few occasions. Their friendship included lots of good whiskey, cards, and hunting. On occasions when John and the earl had been "warmed by a few drops," as the nobleman once described it, Birdwell would introduce his friend uninhibitedly as "the Lord God Aylesford." The Renderbrook Hotel in Colorado City is pictured in 1882.

The T&P Railroad was making its way toward Big Spring, and claims were being staked while the Chinese immigrants continued laying track. John Birdwell constructed a tent (by the springs) made of buffalo hide and sold whiskey in his makeshift saloon. (C. G. Barnett Collection.)

The earl purchased land 15 miles northeast of the springs and built his "castle." It had eight rooms off one long hallway that ran the full length of the house and was built on the upper reaches of Wildhorse Creek, 3 miles north of Iatan Lake. The house was an unpainted board structure, a story-and-a-half high, and "merely comfortable without any sign of luxury," said Annabel Birdwell.

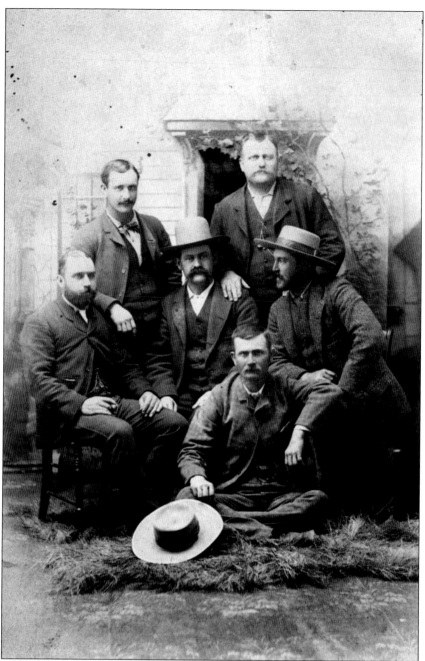

Pictured in the second row are the Earl of Aylesford and his brothers Clement and Daniel "the Kid" Harry Finch. The three arrived in Big Spring along with five servants, a coach, a dog cart, 30 horses, and a lot of "baggage for his Lordship's modest castle on the prairie." Hospitality at the "Texas Castle," as it was called, was unlimited, and empty bottles piled up to haystack proportions. The walls along the hallway were covered with rifles, shotguns, revolvers, derringers, cartridge belts, spurs, game bags, and other articles of the hunting man. John Birdwell is pictured on the floor, and the earl's legal advisor and attorney Arthur Burnard is pictured top right. The man at top left is unknown.

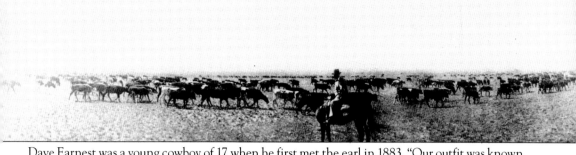

Dave Earnest was a young cowboy of 17 when he first met the earl in 1883. "Our outfit was known as the Deep Creek Outfit," said Earnest. "When I first met John Birdwell he was the proprietor of the Lone Wolf Saloon in Colorado City. John and the earl were best of friends." Earnest continued, "The earl had ridden over from the ranch, to Big Spring to find me, and the earl said, 'I say, Old Top, could you tell me where I might find some good shooting. I have been shooting at that animal you call antelope, but I can't seem to hit them—haven't bagged one yet.' He was dressed in English riding clothes. His saddle was a 'muley'-no horn. As he dismounted, he took from the saddle a flask of whiskey. 'A bit cool this morning, and I'm thinking a few drops of this might not be half bad,' he winked." He and Earnest had several drops, and after breakfast Earnest saddled one of his best horses, got his carbine, and struck out with the earl for Wild Horse and Morgan Creek.

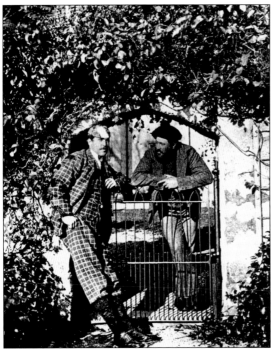

Dave Earnest served as the earl's hunting guide. After several days of hunting, the earl confided in Earnest, "You know, you have been exceedingly kind to a stranger in your country. I try to be one of your Texas cowboys, but the chaps I've met in Big Spring are disposed to make a lot of fun. They don't seem inclined to let me be one of them. I'd like your advice." Shown at left are Clement Finch (left) and Daniel Harry Finch (right).

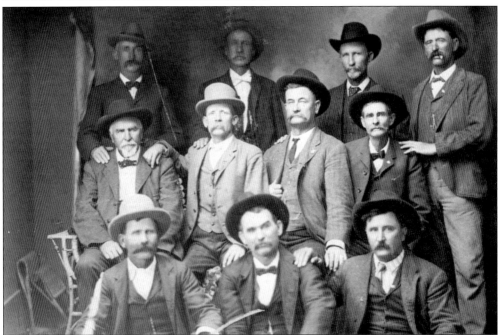

While assessing the earl's clothing, Earnest said, "In the spring about three months from now, when the grass is greening, you'll be going to the Roundups and be meeting some of the best men God ever let live. But they'll devil the life out of you. Beat 'em to it! You're in Texas, not London." The following are, from left to right: (first row) Jack Rogers, John Monday, and Jim Williams; (second row) Jesse Evens, Bud Brown, John Birdwell, and John Roberts; (third row) Dave Earnest, Andy Long, L. S. McDowell, and Andy Jones.

These men were making a cattle trade on the Alderman Ranch. From left to right are George Cauble, Clyde Henry, Tom King, C. L. Alderman, and Bud Cauble. Dave Earnest told the earl, "Hide those English riding boots and clothes. Go down to Colorado City and let Pete Snyder sell you a Stetson. Spend $5 for a pair of Petmecky spurs. Then let that bow-legged Dutchman, Fred Meyers, make you a pair of real Texas boots. Hide that muley thing you call a saddle and spend $50 for a Texas saddle with a California tree, and be sure the saddle has Beef Buyer pockets." Earnest explained that the special pockets were covered with black hair, and they had been introduced by Barry Gatewood, "a big beef buyer who had ridden to the range to look over a big herd of cattle," said Earnest. "Cowboys were much smitten by these fancy pockets on his saddle, and soon they made them a style," he continued. "My word!" mused the earl, "most extraordinary!"

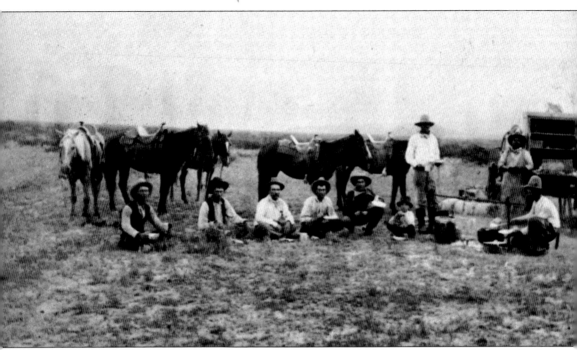

Dave Earnest invited the earl to ride with him on the first spring roundup near Morgan Creek. Approximately 100 men were in the saddle from outfits as far as the Brazos, Concho, and Pecos Rivers. Earnest introduced the earl to Lump Mooney, who he said was "the best cowboy in these parts." Earnest introduced him saying, "Meet the Earl of Aylesford from London, England. He's bought the RUSH Ranch, and he's my nearest neighbor. Help him get acquainted." Mooney eagerly agreed, as he turned and let out a blood-curdling yell that got the attention of everyone. "I'm making you acquainted with the Earl of Aylesford from London, England," he announced in his penetrating voice. "He's bought the RUSH Ranch. Treat him right! He's a neighbor of mine, and I want to keep him in good humor so's I can borrow his tabacca!" (Jess Slaughter Jr. Collection.)

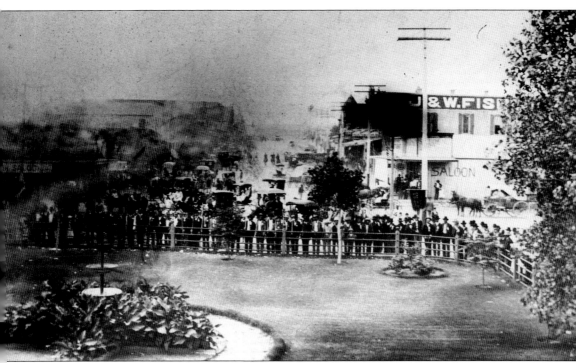

A crowd gathers at the north end of Main Street in the midst of train smoke. Dave Earnest said, "It was our custom, when leaving town about midnight, to shoot up in the air, just to let the natives know we were leaving. One night, the friendly bartender told us the officers were getting peevish over this custom of ours and had announced intentions of arresting all such offenders." Earnest said Lump Mooney was indignant. "How in hell," declared Lump, "will folks know we are leaving town if we don't shoot off our guns?" Earnest went on, saying, "there being no satisfactory answer to Lumps question, we unanimously decided that no Big Spring officer would be permitted to abolish a custom, which had been in effect before they were born!" (Brown Collection.)

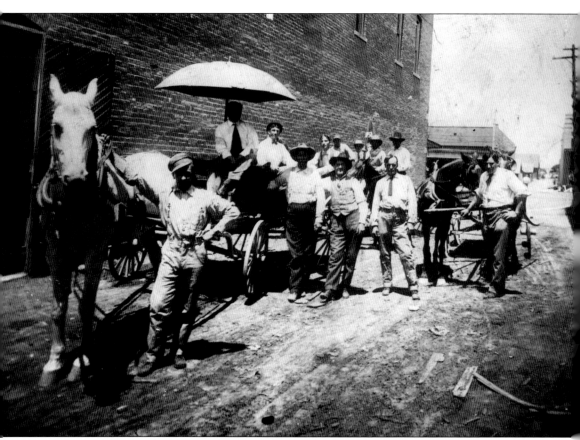

Delivery racks were lined up in the alley behind the Fisher store. Dave Earnest recalled, "There were four of us, as usual, riding our best horses, we commenced to shoot right in front of the J&W Fisher Store right there on the Main street. In order to avoid the officers who were in close pursuit, I rode hell-bent through an alley but nearly reaching the end of that alley, I was nearly dragged from my horse by a clothesline that had been put up by the Chinaman who ran the laundry. Fortunately the clothesline broke but not before all my hide was scraped from my face."

Sam Lee owned the laundry by the Fisher store. The cowboys made Lee's life unpleasant to say the least. They would run through his clotheslines shooting their six-shooters outside his door, causing Sam and his employees to run out in the street terrified. The Fisher boys—Albert, Bernard, and Joye—enjoyed watching Lee take a mouthful of water and sprinkle the clothes with it. (Fisher Collection.)

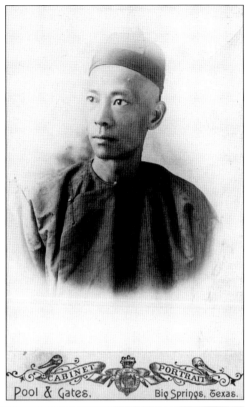

Pool & Gates. Big Springs, Texas.

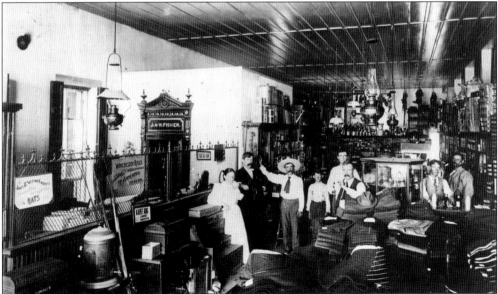

Thieves tried to break into the J&W Fisher Store by sliding under the building using an auger and bit to drill through the wooden floor; however, they drilled into a vinegar barrel, and the contents emptied on them, souring their efforts. The Fishers then erected a stone structure and eliminated the chance of a thief coming in under the building. Pictured in the photograph are Fisher's clerks W. J. Crawford and Jack Smith. (Brennand Collection.)

One of the cowboys said, "The Judge would open a bottle of whisky for any cowboy who dropped in. He doesn't stop at one neither; I've been to the ranch many a time to stay all night, and wake up in the morning to find the bottles lying around thick as fleas, the boys two deep on the floor snoring' like mad buffalo and the Judge with a bottle in each hand over in the corner."

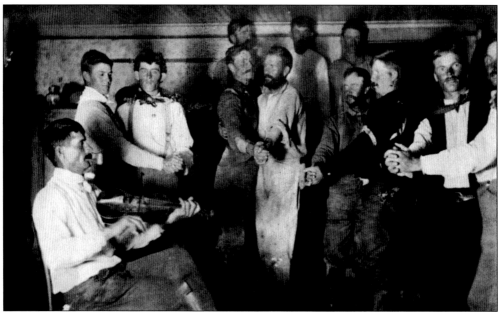

In the late 1880s, the cowboys entertain each other. The earl's ranch house burned, destroying his collection of priceless guns, some of which had been handmade for his hunts with the Prince of Wales. He rarely returned to his ranch due to his declining health. Dr. Utter, the earl's private physician, told him many times, "Your drinking is going to kill you." "Ah, but what a way to go," was the earl's reply.

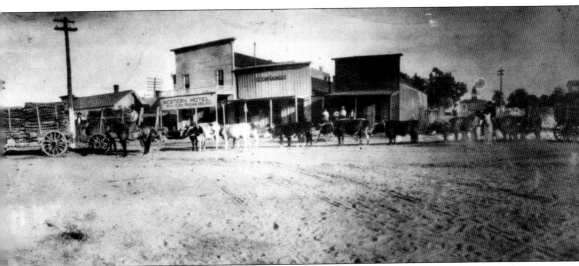

Buffalo hunter John Whalen and his partner Charlie Pryor became agitated with one another during the division of their money in a Big Spring saloon. The men had made their money from a railroad car of buffalo and wolf hides. Whalen was a heavy drinker and went around town swearing to kill Pryor. As a result, Pryor decided to call his bluff. Whalen was dealing in a monte game when Pryor walked in and laid down a "two-bit piece" on the table. Someone said that a dishwasher standing nearby picked up the money and snuck off without being seen by Pryor or Whalen. When Pryor's card was turned up and Pryor demanded his money, the 50¢ piece could not be found. Whalen accused Pryor of never putting down the piece. Both men then drew their guns, but Pryor had the advantage since he was standing and Whalen was sitting. Whalen was shot through the heart and Pryor through the hip. Pryor's wound was not fatal. This 1884 view from Front Street shows Western Hotel, Steam Laundry, and the Limestone Courthouse at far right.

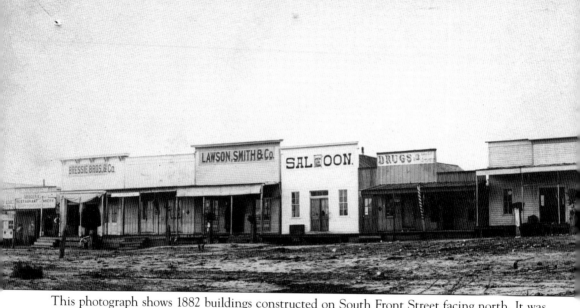

This photograph shows 1882 buildings constructed on South Front Street facing north. It was said that blood flowed as freely as water in the early days of Big Spring. Charlie Little was killed in another roughhouse killing at the Nip 'N Tuck Saloon, run by George Bauer and Cal Williams. There had been a dance in the second story of the old courthouse, and someone had thrown a bottle through one of the windows. Joe Love, one of the residents, was accused of the misdemeanor because he had just had a misunderstanding with his girlfriend. His accusers met him in the Shamrock Saloon, and they engaged in a fistfight since Love didn't have his gun. After the fight was over, Love left to get his gun and washed the blood from his face. He returned to the saloon and opened fire on his accusers. Caught in the open hail of gunfire, Charlie Little, who had nothing to do with the argument, caught a bullet. As it turned out, he was the only one killed. Joe Love then obtained one of A. G. Denmark's horses and left town. The horse later returned without the rider.

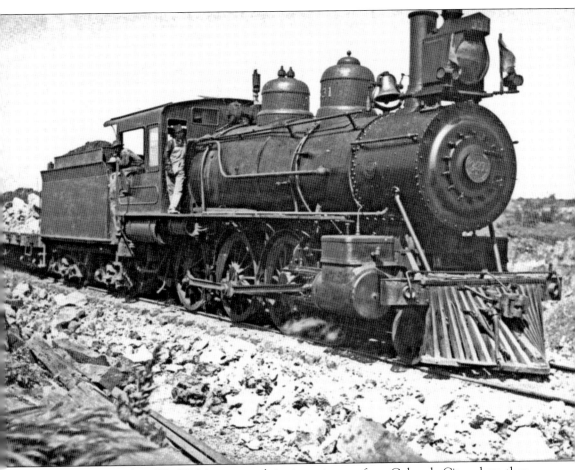

On June 2, 1885, Sheriff R. W. Morrow was bringing prisoners from Colorado City, where they had been housed pending the completion of the Howard County jail. One of the prisoners jumped off the train and tried to make an escape. Morrow shot a few rounds from his long-barreled Colt 45 to scare him, but one of the bullets ricocheted, hitting the prisoner. Morrow cried, "My God, I'm afraid I have hit him. I would not have hurt him for anything in this world." Bending down over the prisoner, Morrow asked, "Are you hurt?" The prisoner said, "Yes, I am killed, you have killed me. I am shot!" Morrow cried in anguish, "I had no idea of hurting you; I would not have done it for $10,000!" Upon arrival in Big Spring, the prisoner was taken to a drugstore where Dr. W. F. Standiford removed the bullet, however he did not recover.

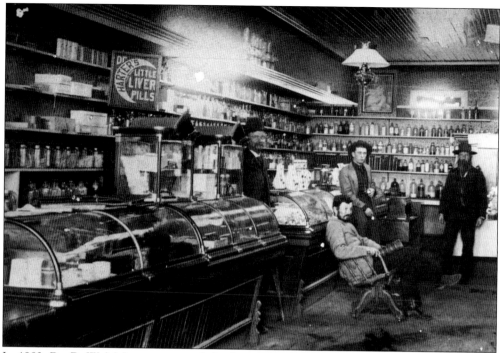

In 1882, Dr. D. W. McIntyre acquired the Bacon Drug Company, one of the first drugstores in Big Spring, located on Main Street. Dr. McIntyre, seated in the chair, eventually sold the drugstore to Bascum Reagan. County land surveyor R. B. Zinn (with beard) is pictured in back. (Hurt Collection.)

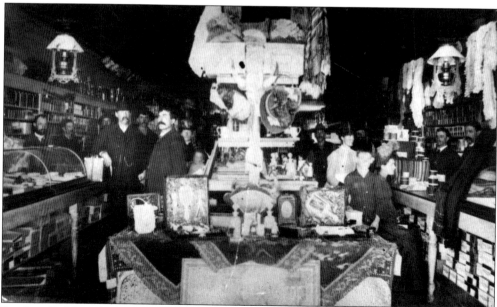

Brothers R. M. and P. E. Bressie set up a general-merchandising shop in 1881. Brother-in-law Albert G. Denmark joined the brothers in their two-story rock building located across the alley north of the Fisher store on First Street. The Fishers eventually purchased the store from Bressie and Denmark. (Choate Collection.)

Two

1890s BIG SPRING
THE BIRDWELL FAMILY

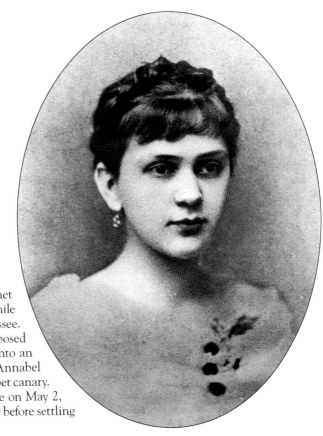

At the age of 34, John Birdwell met his bride-to-be, Annabel Green, while visiting his stepmother in Tennessee. After the third visit, Birdwell proposed and had a $20 gold piece made into an engagement band and sent it to Annabel inside a box of red peppers for her pet canary. The couple married in Tennessee on May 2, 1883, and moved to Colorado City before settling in Big Spring.

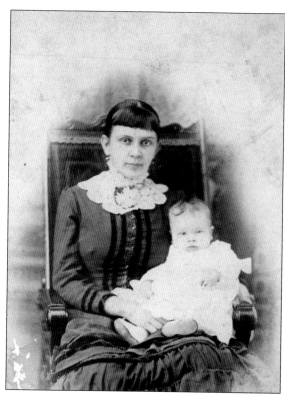

The earl built a home for the Birdwells. He then hired John to break horses for him. "It was a small house, little better than a shack" said Annabel, built on what was known as "Mexican Hill." The couple welcomed their firstborn, Lillian Elizabeth Birdwell, on June 22, 1884.

The Birdwells added two more children to their family: Annabelle was born August 1886 and Daniel Finch (named after the Earl's brother) in 1888. For a short time, John and Annabel managed the Cosmopolitan Hotel for the earl and then became proprietors of the T&P Hotel.

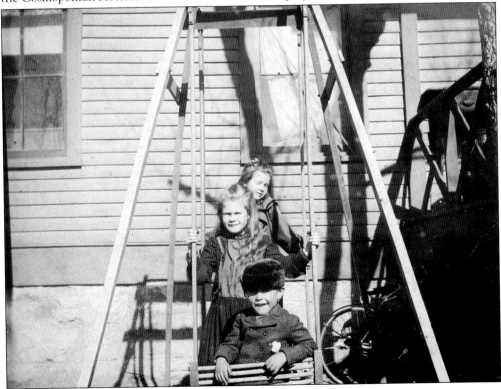

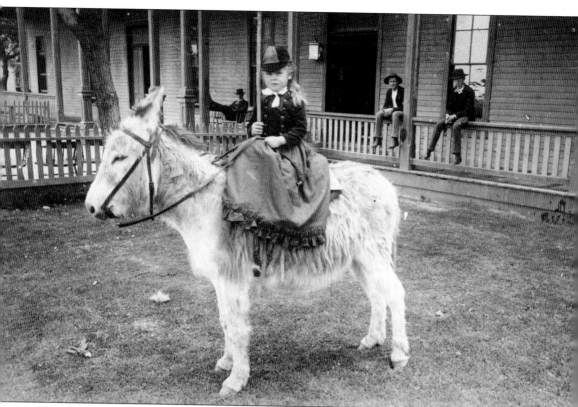

Lillian Elizabeth (sitting on donkey) recalled Christmas at the T&P Hotel in 1890. "There was always a big tree, with green and red berries and Spanish moss, which was shipped in a boxcar by the railroad. Our ornaments were handmade out of tin. We strung popcorn and cranberries by the yard. There were plenty of red apples, oranges, candy sticks and hard candies and various nuts. We pulled taffy, made peanut brittle and molasses candy and enjoyed plenty of apple cider and fruitcake. Hing Lee made lots of delicious things to eat in the kitchen. We hung popcorn balls and candles on the tree that stood in the dining room for all to enjoy. There were two large iron posts, which were entwined with cedar branches dipped in flour to remind you of the snow. Days before Christmas, Papa would carry two large boxes marking one for girls and the other for boys. They were filled with presents, oranges, apples, candy and nuts all tied in a piece of beautiful mosquito netting of green or red. He handed these out to every child he met." (Lillian Birdwell.)

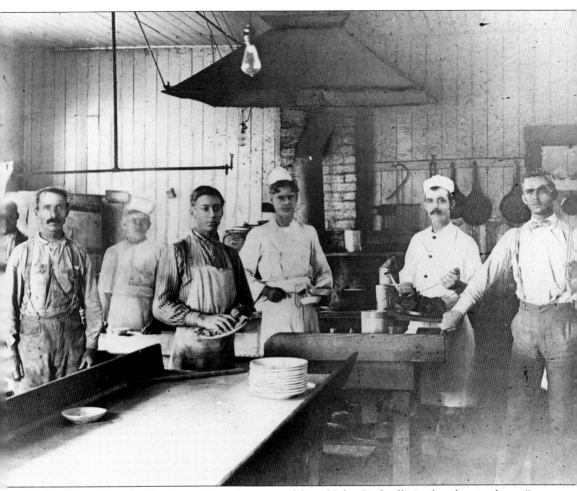

Jeff Milton stopped off at former Texas Ranger and friend John Birdwell's "railroad eating house" for dinner. Rabbit stew was the dish of the day. Milton took one look and declined. The waitress, however, was insistent that he have rabbit stew as it was "very nice rabbit stew." She kept on insisting until Milton's honesty overcame his Southern breeding, and he blurted out, "Take it away, I've boiled too many prairie dogs in my time and any fool knows that rabbit bones aren't red." The Birdwells had loyal employees, and in turn they were loyal to them. One of John's deputies was involved in a crap game with several African American men. "An argument ensued, followed by a fight and shooting, leaving the deputy dead." Annabel said, "It was like pouring gasoline on the town. The whites decreed that every Negro had to be out of town within 24 hours. Our employees were terrified." Annabel ordered her employees to hide in her bedroom until they could safely leave town. John Birdwell is on the far right in the hotel kitchen with his employees.

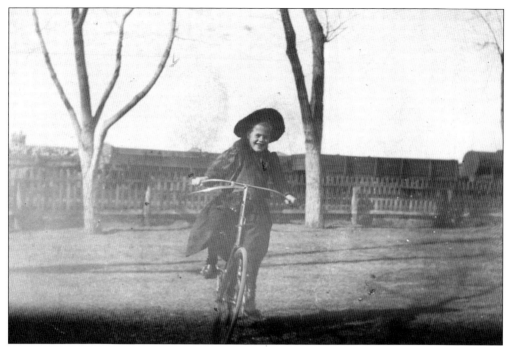

"I was overjoyed to receive a pair of black, high topped button shoes with beautiful red tops and the prettiest black silk tassels that would swing when I walked. Friends came to see us during the holidays. They often brought little gifts they had made: fancy needlework, cakes, and pies. It was such a joyous time!" said Lillian Birdwell, who is pictured here on her bicycle.

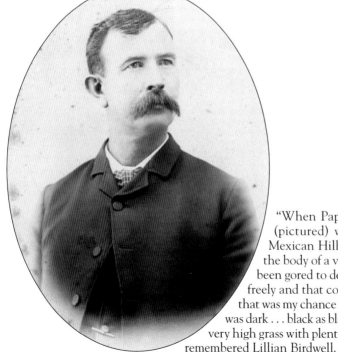

"When Papa was Sheriff and Uncle Bill (pictured) was deputy, the Mexicans on Mexican Hill were celebrating the return of the body of a very famous bull fighter who had been gored to death. A lot of drink was flowing freely and that could mean much trouble. I knew that was my chance to see this famous Bull Fighter. It was dark . . . black as black could be. I had a long walk in very high grass with plenty of diamond back rattlesnakes," remembered Lillian Birdwell.

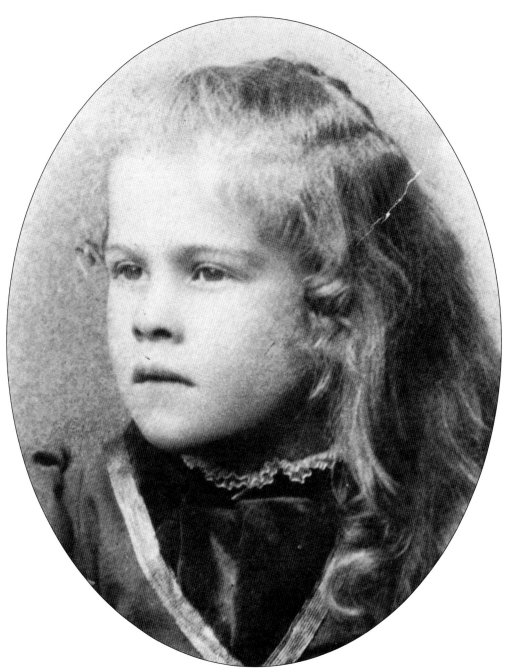

"When my Uncle Bill arrived on Mexican Hill, he spoke to the men and then went into the dugout to pay his respects to the hero of the night. Behind the bull fighter, in this dugout, was an altar that had been made and covered in a white cloth surrounded by candles. The hero was in one of his bullfight uniforms, all gold braid and fringe. The bullfighter had been placed on planks that were on carpenter horses with tubs of ice to preserve him and his support was covered with a beautiful green felt covering bordered with elegant red fringe with green and gold tassels. I slipped under the hero and rose up to see him when my Uncle grabbed me. I had loved every second of my adventure and my wonderful loving uncle never told Papa," said Lillian Birdwell.

43

Despatcher's Office,
Big Springs, Texas

Annabel Birdwell decided that the hotel, which ran adjacent to the railroad tracks, was no place to raise children. She and John purchased a half section of land. "We picked out the crown of a hill (Tenth and Goliad) and decided that this was the spot," said Annabel. They built a large wood-frame house, servant's quarters, and barns, with an earth and rock dam along the draw to the east for a water supply.

Shortly after John and Annabel BIrdwell moved into their new home, the Mollie Bailey Circus came to town. John took the children to the show while Annabel stayed home and took a nap with baby Johnanna. She had just dozed off when she was awakened by a baby's laughter. She looked up to see the ceiling bathed in flames billowing in at Johnanna's crib. Annabel grabbed the baby and quickly fled from the house.

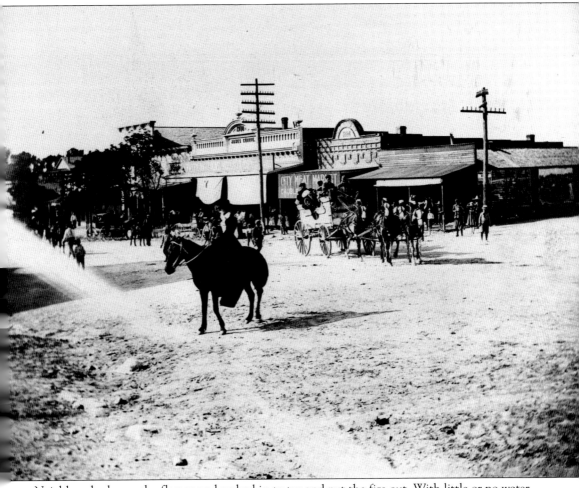

Neighbors had seen the flames and rushed in to try and put the fire out. With little or no water to work with, the fire quickly consumed the Birdwell home and all of the family's possessions. Annabel stated, "Two men grabbed the china cabinet but in their rush, they opened it and started tossing out the plates." In the end, only a dresser and a handful of items were salvaged. The flames were seen from town, and people soon crowded around with offers of sympathy. Annabel knew if the family had all been at home, the devastation could have been far more severe. She could only mutter, "Thank God for Mollie Bailey!" One of the lady's retorted, "Humph! I'll bet that's the only time anyone ever thanked God for Mollie Bailey." Bailey is pictured on horse in 1901.

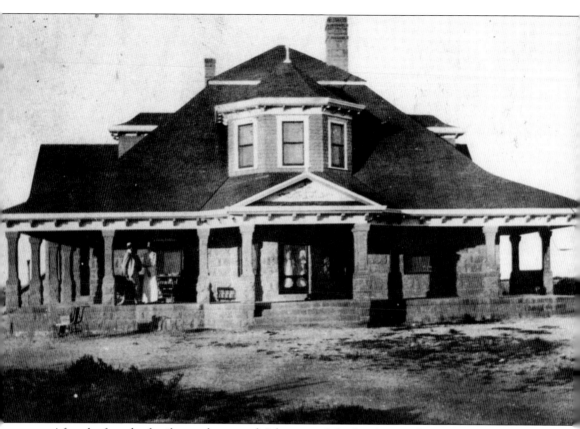

After the fire, the family was devastated. John moved the family into the servant's quarters and resolved to raise another house on the spot. He said he had only two specifications, "Make it big enough, and make it so it won't burn." With that request, he turned over the design to Annabel. John ordered the stone from the Quito Quarry, and the Pecos sandstone was cut and numbered and individually wrapped. The massive stones were a foot thick. It allowed for the house to be cooler in the summer and more insulated in the winter. Most importantly, it added fire protection.

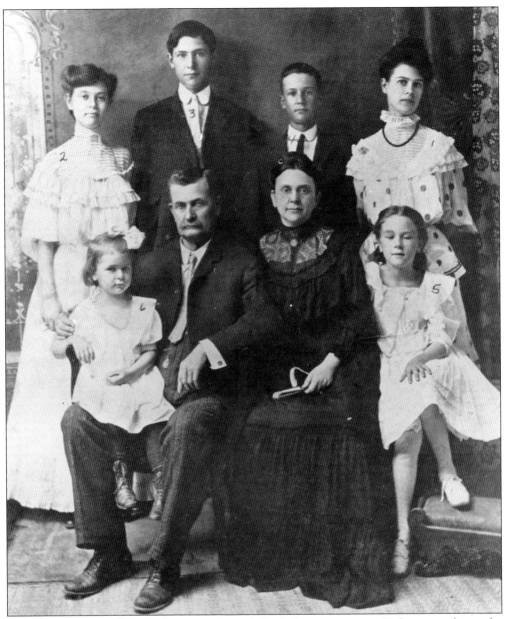

A large, spacious kitchen, bathroom with a tub, butler's pantry, master bedroom, parlor, and a music room with a Steinway grand piano made up the first floor. A porch wrapped around the front and both sides. The second floor consisted of a middle room where the stairwell came up. The stairway was flanked on the north side by the girl's room, which had a playroom off it, and a boy's wing along the south side. Between the boy's and girl's rooms was a cupola room, and on the east was a guest room that overlooked the pond. One of five fireplaces was in the dining room and back to back to a fireplace in the reception room. John had his Masonic emblem carved into the stone mantle. On the east wall of the living room, another fireplace was back to back with one in the music room. "Many evenings were spent gathered around the fireplace, popping corn and telling stories," said Lillian. Pictured are, from left to right, (first row) Johnanna, John, Annabel, and Maydell; (second row) Annabel II, Daniel Finch, Banton, and Lillian.

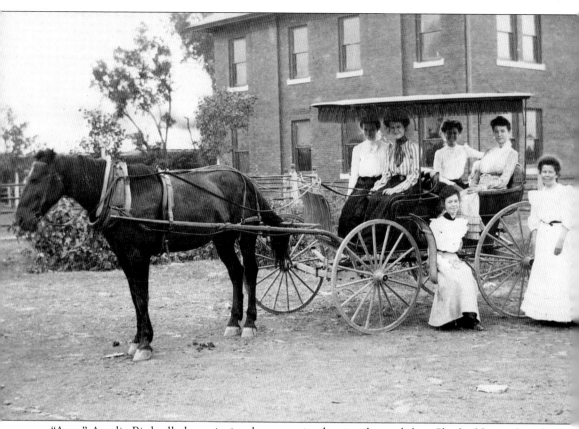

"Aunt" Amelia Birdwell always insisted on carrying her jewelry with her. She had been abroad many times and had quite an extensive diamond collection. She wired the Birdwells and told them she would be arriving and requested that someone pick her up at the depot. Lillian volunteered for the job and set out to meet Aunt Amelia's train at midnight. Lillian said, "Papa instructed me to bring my colts which he had taught me how to use. The rain was starting to come down in sheets so the storm curtains were put on to Mama's surrey. The streets did not have lights or pavement. There were two deep gullies on each side going down Goliad. We crossed these gullies on wooden bridges that weren't very wide. The only light we had was the lightning. Old Bert (Papa's horse) and I headed for the T&P hotel. I had to guide Bert into the back way through a narrow gate. On either side of the drive after you passed the gate, were several different buildings, the laundry, ice house, and chicken house."

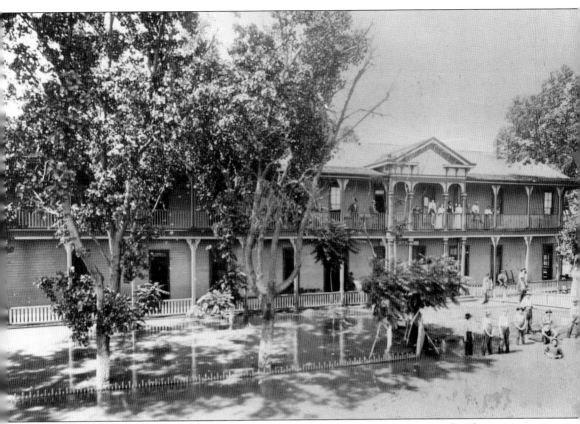

"Earlier in the day, Papa had discharged an employee from the hotel (pictured). This man was caught hiding in a room with two young girls and Papa was very upset over the matter. As I entered the hotel yard area, the man grabbed at Bert's reins on the left side. Bert lunged and reared up breaking the reins and I fired my gun at him. The man disappeared and Bert and I continued on our journey with only one rein leading me to the hitching post. Papa came running out and looked Bert over to see if there were any knife wounds and luckily there were not. He replaced the old reins and we picked up Aunt Amelia," remembered Lillian Birdwell.

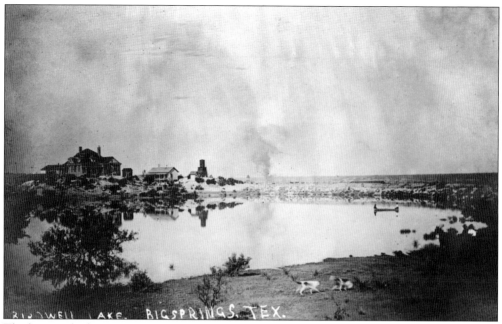

The house relied on a cistern, which was operated by a hand crank that turned a long chain of small buckets. The bucket came over the top of the ratchet wheel, dumping the contents into a little basin that drained over charcoal into a spout. This photograph shows the back of the Birdwell home overlooking the pond.

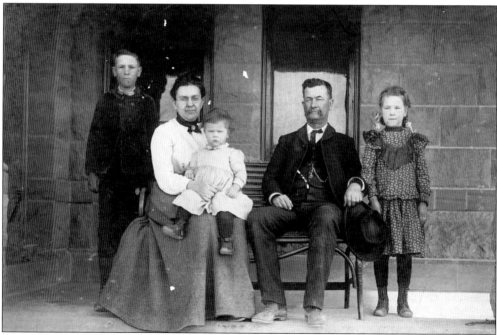

In 1888, Sheriff John Birdwell was in Fort Worth on the trail of a murder suspect. John was so proud of his "catch" that he wanted to name his new son after the murder suspect (Toots). Annabelle would not hear of it, and they settled on William Banton. Pictured are, from left to right, Banton, Annabel, baby Johnanna, John, and Maydell.

Three

THE 1900S
BUILDING AND STAKING CLAIMS

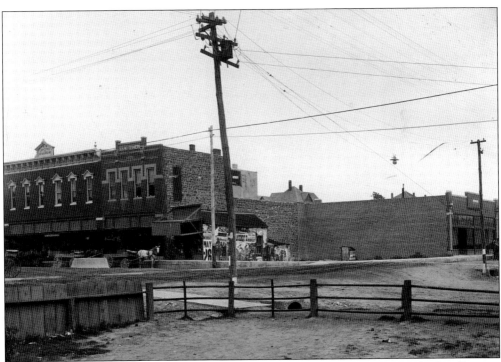

Here is the J&W Fisher Store around 1909 when the concrete water troughs and sidewalks were added. The store was established in 1882. Gradually the Fishers increased their stock and their clientele. Soon they called it the "store that has everything." Mary Zinn remembered the store had everything from a card of straight pins to a threshing machine. "The Fishers were accommodating people and as straight as string."

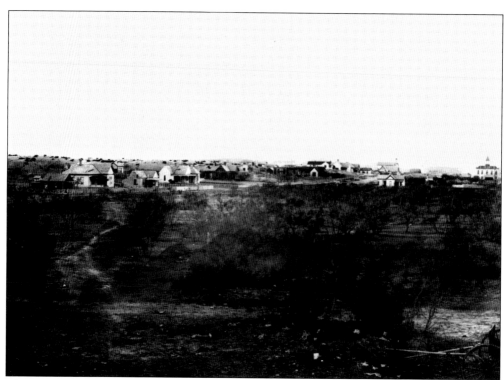

The photograph above shows Big Spring in 1882, viewed from the south looking northwest. The limestone courthouse, constructed in 1884, is shown to the far right. The photograph below was taken from the southeast looking northwest to the limestone courthouse. The newly built courthouse became a favorite gathering place for townsfolk. (McDowell-Alderman Collections.)

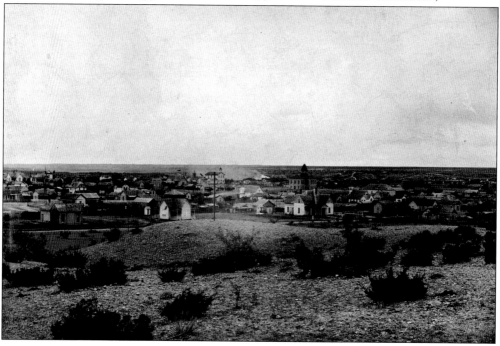

The 1903 Reclamation Act opened the Mexico borders for laborers. The act was devised to bring people to Texas to help clear, cultivate, harvest, and irrigate the land. Immigrants migrated into Big Spring, where they began to work in the fields, on ranches, and for the railroad. In the photograph at right are, from left to right, Plutorca (Luta) Mendez, Eulalcia Jora, and Tomosa Mendez Garcia. In the photograph below are, from left to right, Arnulfo M. Hernandez, Alberto (Boto) Garcia, Augustin Sanchez, Andemio J. Mendez, and unidentified. (Hernandez Collection.)

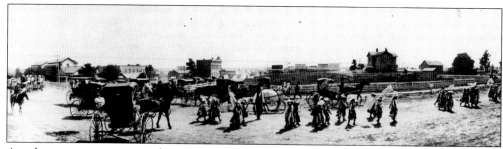

Another institution ingrained in Big Spring from the start was the parade. It did not take much provocation for a parade, and certainly this 1900 Independence Day was the occasion. Residents dressed up, carried their flags, marshaled their buggies and wagons, and celebrated the Fourth of July. (G. T. Hall Collection.)

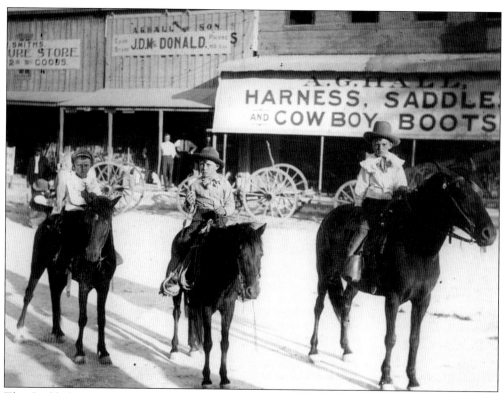

The Cauble boys (pictured) were the sons of Euclid and Julia Mary Cauble. The family came to Big Spring in the late 1800s to join older brothers George, Isaac, Sam, Frank, James, and William Cauble in ranching interests on land southwest of Big Spring. (Cauble Collection.)

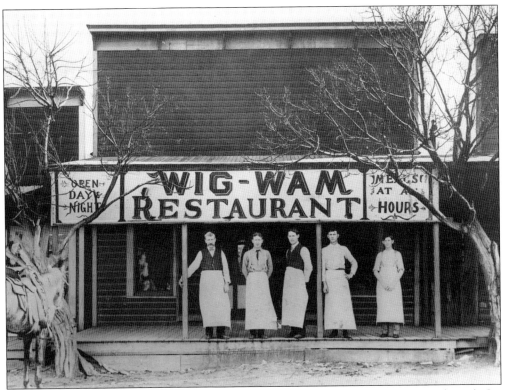

In 1906, The WigWam Restaurant was opened by John C. Horn (pictured with employees). On Sunday morning, June 6, 1907, smoke was seen coming out of the roof of the restaurant, located on the east corner of Main and First Streets. The fire destroyed the entire block of buildings. Damages to the WigWam were listed at $6,000. (Pickle Collection.)

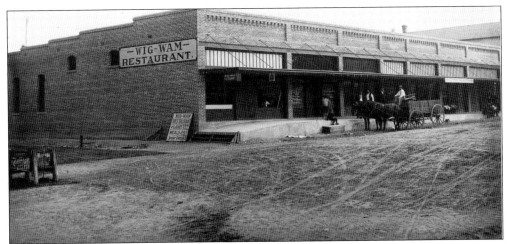

The new WigWam Restaurant was reconstructed, and owner J. C. Horn claimed it was the most up-to-date restaurant in the West. A hot cup of coffee cost a nickel. Pictured is Jesse B. Ryan, an engineer for the T&P Railroad, in the wagon. This section of buildings was constructed on the lower end of Main Street. (Alden Ryan Collection.)

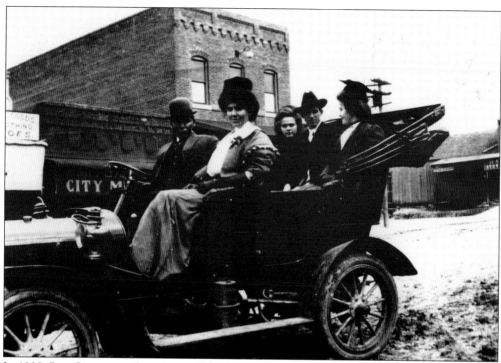

In 1908, Ben Garner purchased one of the first internal-combustion automobiles in Big Spring. Pictured in front of the City Meat Market on Main Street are Ben and his wife, Bell Mann Garner (seated in front). Hattie Mann (left) and Ernie Reagan Brindley are seated in back with an unidentified man.

In 1909, Western Telephone Company installed the first telephone pole in Big Spring. Each switchboard number required a separate line, with several parties on one line. There were 83 subscribers with one- or two- digit telephone numbers. However, the number of subscribers never surpassed 100. Low subscription prompted owner C. W. Roberts to strike a deal with the Alderman brothers to take over the system.

In 1904, Tom E. Jordan and his brother-in-law Will G. Hayden established the *Big Spring Herald*. It was the third newspaper to appear in Big Spring. The first newspaper, the *Pantagraph*, started in 1883, followed by the *Enterprise*, and finally the *Daily Venture*, before the turn of the century. The modest wood structure was located at 300 East Second Street.

The first rancher in Howard County was David Rhoton. A mild-mannered and wiry man, he was deeply religious. He, nevertheless, had a steely temper when his Irish ire was aroused sufficiently. Rhoten arrived in Howard County in 1879 but left briefly, which enabled W. T. Roberts the opportunity to move into the same area and make the claim of first pioneer. Pictured are Dave and Frances Rhoton.

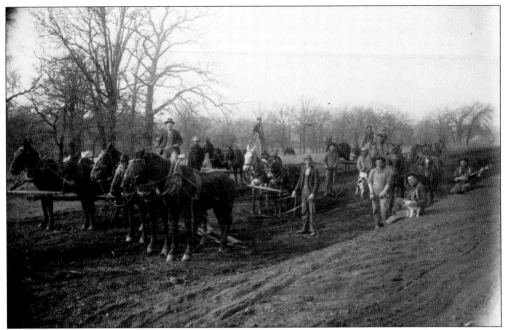

The first roads in Howard County were carved out by the buffalo, which crossed the plains in vast herds. Work crews with teams of horses and mules used Fresno box plows and pulling slips to scoop and drag the dirt a fraction of a yard at a time. This crew is plowing through the old Cottonwood Park and building the Bankhead Highway at Third and Birdwell Streets. (Tucker Collection.)

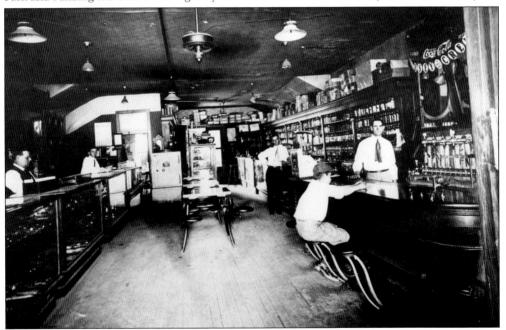

J. D. Biles, owner of Biles Drug Store located at 114 Main Street, is standing at the far right behind the counter. Advertised in 1919 were two bottles of white pine and tar cough syrup on sale for 61¢. Other items available for purchase were kidney pills, stationery, house paint, tar soap, and an extra enticement for the customers was to try a fruit salad sundae at the soda fountain.

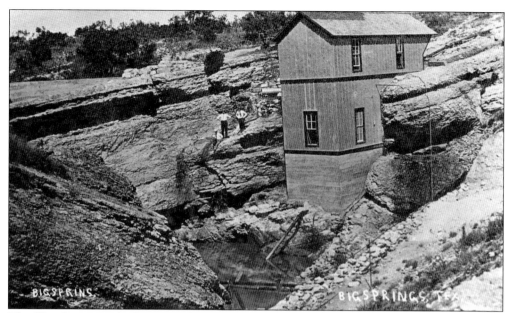

The "Big Spring," which spawned and gave the town its name, was long the mecca for the Comanche and endless herds of buffalo. Later the Texas and Pacific Railroad capitalized on the spring as a source of water for its thirsty locomotives in the westward thrust. By the late 1880s, the level of the spring had already been pulled down drastically by this pump station.

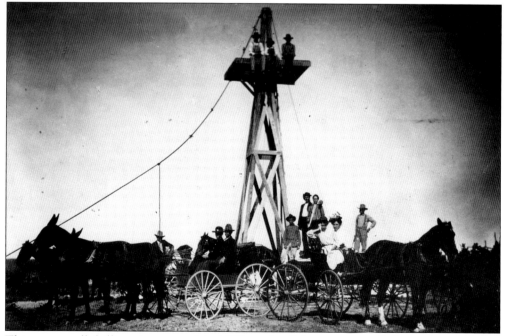

This water well drilling rig was used in 1906 on the Cole property at Eighteenth and Goliad Streets. Oil was found on W. R. Cole's drill bit, so he plugged the well and moved over "drilling himself a good well of water," said daughter Jo Cole. Townspeople purchased water from water haulers who peddled their wares at 25¢ to 50¢ a barrel. Residents signaled to their favorite hauler by hanging out different colored flags.

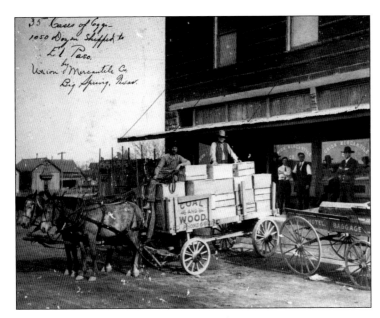

The Union Mercantile Company, located on East Second Street, is getting ready to ship 35 cases of eggs to El Paso. From left to right are Tom Smith, W. R. Cole, unidentified, Sam Smith, Doc Kincaid Jr., and Will Carpenter. The Cole Hotel baggage wagon is shown to the right. (Cole Collection.)

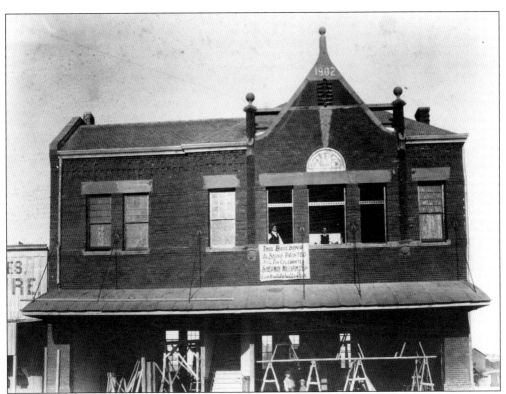

The Masonic Temple, located on the northeast corner of East Third and Main Streets, was completed in 1902. The Free and Accepted Masons was the first fraternal body to organize in Big Spring. The organization constructed the two-story building, allowing the Masons to lease the bottom portion out for revenue. The exterior of the structure has since been finished with stucco, and the Masons have celebrated over 100 years in the same building.

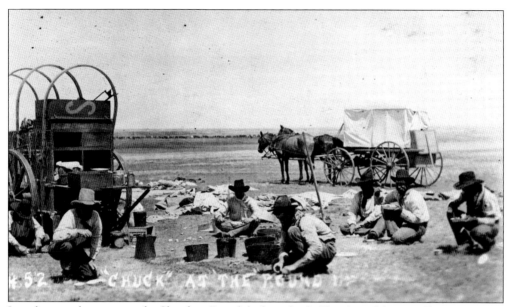

It took seven days to cross the Slaughter Ranch by horseback. Slaughter did most of his inspections on horse and later in what he called his "By-God." This was a wagon with four double-yoked oxen that were sometimes slow at getting started, but when he added these words, "By-God gedap," the oxen would pull the wagon ahead. Pictured is Col. C. C. Slaughter having dinner at his roundup in Tahoka.

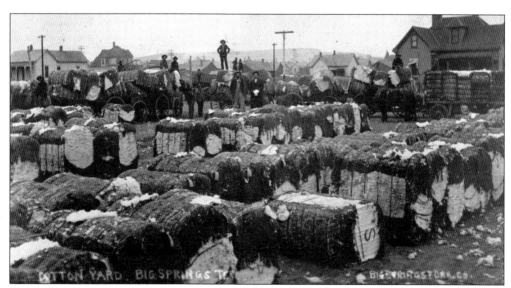

The first cotton planted in Big Spring was in 1885 by J. B. D. Boydstun. He broke 4 acres and planted it in cotton yielding two bales. Records indicate the first cotton gin erected in Howard County was in 1897. By 1907, the gins could turn out 6,000 bales per season. As more land was broken and planted, more gins were added. At one time, Howard County had 10 gins running.

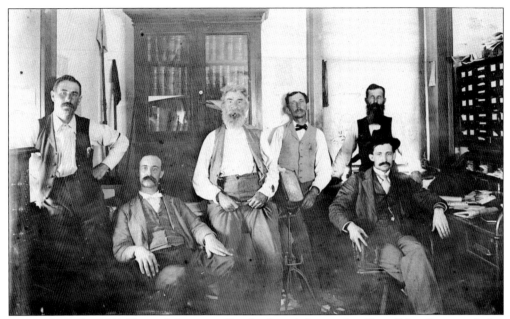

Pictured are the 1901 Howard County officials, from left to right, Sheriff Jim Baggett, Judge John Littler, Dr. J. W. Barnett, clerk Andrew Walker, county attorney Ellis Douthit (seated), and surveyor R. B. Zinn (with beard). Law and order had to be quickly formed in newly settled Howard County. Ike Eddins, first justice of peace, is quoted as saying that "the first six people buried in the cemetery, met death violently," in the book *Gettin' Started* by Joe Pickle.

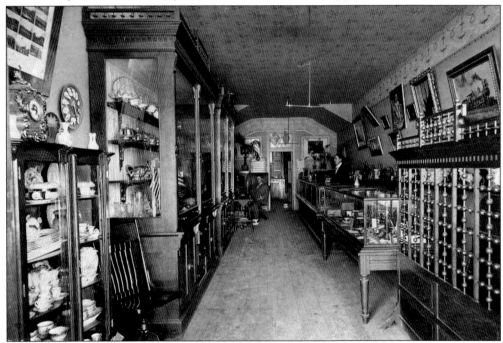

In 1890, Irvin H. Park Jewelry store, located at 114 Main Street, was established. The store carried a line of diamonds, watches, silverware, jewelry, cut glass, and hand-painted china. Park was respected as a fine photographer as well as the watch inspector for the T&P Railroad.

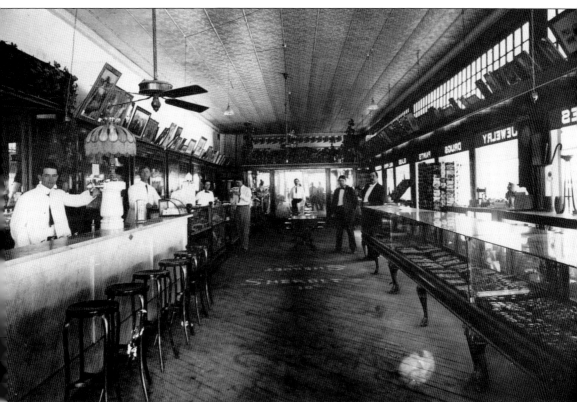

Dr. Granville Hall began practicing medicine in Big Spring after graduating in 1906 from the University of Texas. His office was located above the J. L. Ward Drug Store (pictured). In 1910, Hollie Shick summoned Dr. Hall after she became ill. The young doctor recognized the symptoms and successfully performed the first appendectomy in Big Spring at the patient's home. Newspapers were soaked in formaldehyde and used to chink every window. A tub was put on rocks and formaldehyde burned all night to fumigate the room. Kerosene lamps were used for the best lighting possible. Dr. Hall had sent for three graduate nurses from Fort Worth to assist him. His examination table was brought from his office to serve as an operating table. Dr. Hall joined Dr. Bennett and built the Hall and Bennett Hospital in 1928. (Hurt Collection.)

W. P. Soash purchased 175,000 acres from C. C. Slaughter for an astounding $3 million. Soash advertised his land, located 5 miles west of Vealmoor, to prospectors in hopes that the Santa Fe would run through Lamesa. He was able to pull some strings and obtain a post office while a group of Germans built a Catholic church. In 1909, a two-story concrete office building was constructed for the land company, a hotel called the Lorna, a general store, drugstore, two barbershops, livery stable, bank building, and a garage. The Santa Fe did not pass through Lamesa, and people from Lamesa would not move to Soash. Many of the settlers gave up hope after a four-year drought followed. Soash wired Slaughter for $75,000 to "keep from going under." Slaughter's telegraph replied, "Go under."

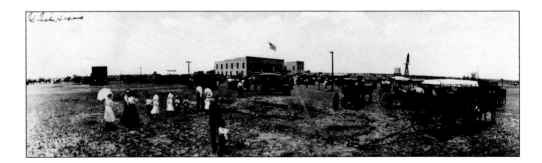

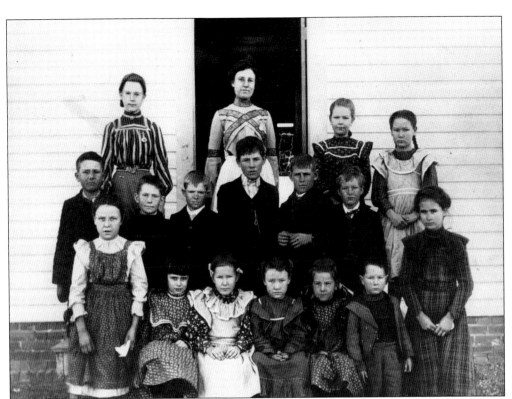

John Birdwell constructed a small-frame building to serve as a private school for his three younger children to attend. His cousin Adeline Hyde and his wife, Annabel, taught there. Pictured above in 1902, in the first row third from left, is Maydell, and Banton Birdwell is in the second row far left.

By the time Johnanna was born on December 4, 1900, John Birdwell grumbled to his wife, Annabel, "You never thought enough of me to name one of the children after me, and now it's a girl!" Allowances were made, and Johnanna was named for her father.

The *Big Springs Pantograph* published this wedding notice: "Forth from the curtain of clouds from his tent o purple and gold, issued the sun, the Great High Priest, his garments resplendent, blessing the world as he came, and flooding 'Red Rock,' the beautiful home of Mr. And Mrs. John D. Birdwell with warmth and gladness, making a perfect wedding morn for Mr. Edward Mills, a prominent traveling man, and Miss Lillian Birdwell, the eldest and stateliest daughter of the home. Promptly at 7:30 o'clock on the morning of July the twenty-sixth, nineteen hundred and four." Lillian had been dating another young man and had to choose which invitation of marriage to accept. She later said she chose the gentlemen with the largest engagement ring.

Four

THE TEEN YEARS
HARD WORK AND UNITY

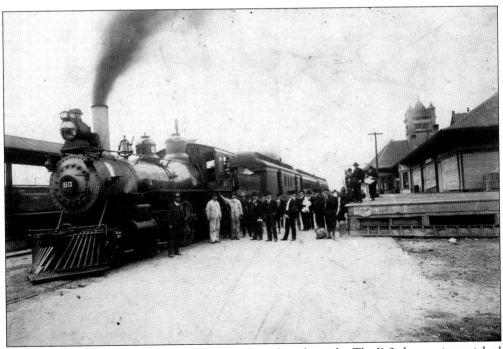

The early locomotives were wood burning with funnel smokestacks. The D-2 class engine weighed over 45 tons and could average up to 40 miles per hour. Passengers are waiting to board the train at the T&P depot.

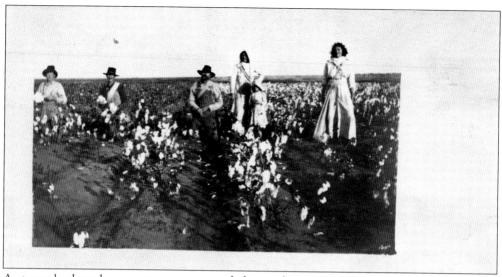

A strong back and perseverance were needed to gather cotton when it began to flourish in Howard County just after 1900. Planting and cultivation was done with mules, and harvest was done by hand.

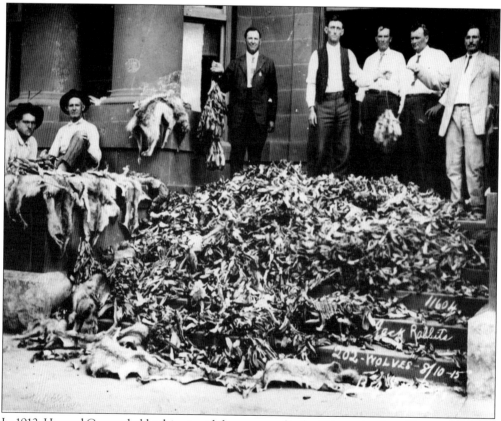

In 1912, Howard County held a drive to rid the county of jackrabbits and wolves. During the drive, 11,604 jackrabbit ears and 202 wolf hides were shown as evidence on the steps of the courthouse. The rancid odor quickly prompted county officials to burn all of the scalps and ears.

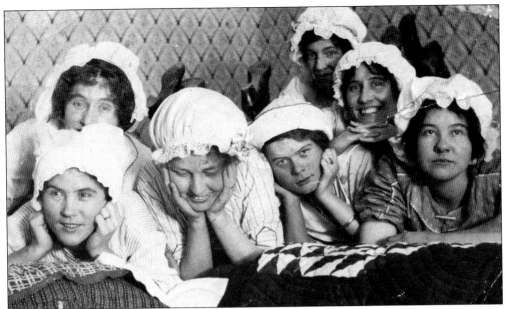

"In The Good Old Summertime" was a popular song at this 1914 slumber party. Shown from left to right are (first row) Mary Coffee (Cole), Mamie Alexander, Lottie Griffith (Sefton), and Katie Alexander; (second row) Abbie Lou Hefley, Hilda Majors, and Mattie Hefley.

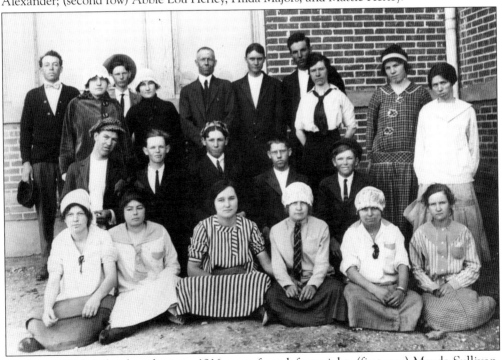

Coahoma High School students in 1916 were, from left to right, (first row) Maude Sullivan, Leighton Wolf, Winnie Dell Rhoton, Lena Riley, Donna Smith, and Eldin Riley; (second row) J. B. Collin, Elbert Echols, Harry Echols, Cy Shaw, ? Ellis; (third row) Vernon Guthrie, Jewell Neal, Leroy Echols, Netti Wasson, Mr. Shaw (teacher), ? Boren, Bradley McQuarry, Gladys Sullivan, Eva Beasley, and Leonard McGregor. (Rhoton Collection.)

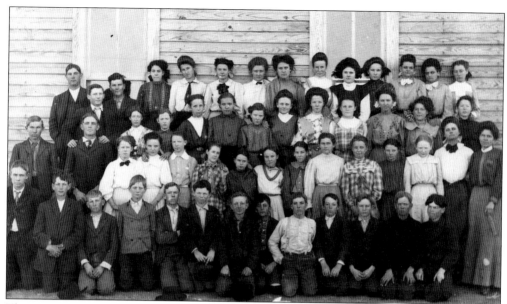

The Coahoma student body and school are pictured above in 1910. The building was originally located on the Stella Jackson farm, northeast of Coahoma. Some of the boys in the first row conspired to show their naughty sides. (Phinney Collection.)

The average wages in 1900 were $963 yearly, and a new home could be purchased for around $4,000. This 1910 Tin Shop was located at the 200 block of East Second Street. H. B. (Henry) Arnold, the owner, and James R. Sanders (farthest from camera) are in the background. (Creighton Collection.)

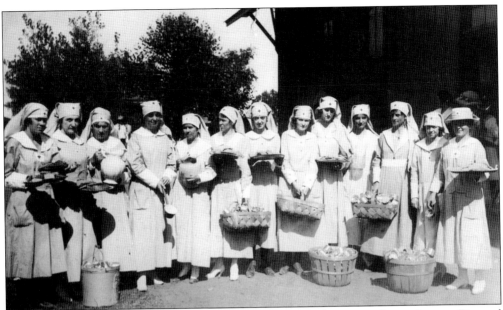

In 1917, the Red Cross Ladies met the trains and gave out refreshments to the servicemen. Pictured are, from left to right, Bobbie Nall, Mabel Ricker, Mrs. Leo Nall, Mrs. J. T. Brooks, Mrs. J. B. Nall, Frankie Kent, Vera Wills, Margaret Compton Mabee, Jane Holmes, Kate Eason, Mrs. F. B. Blalack, Bell Gary, and Verbena Barnes.

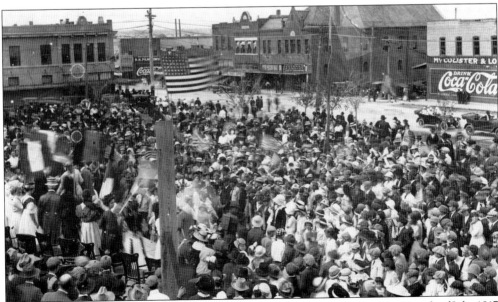

Celebrations and crowds were a surefire combination, but never more so than Fourth of July, 1917, when patriotic fever was at an all-time high, as America was plunged into a world war. The crowd was gathered on the northeast corner of the courthouse lawn. (Pancoast Collection.)

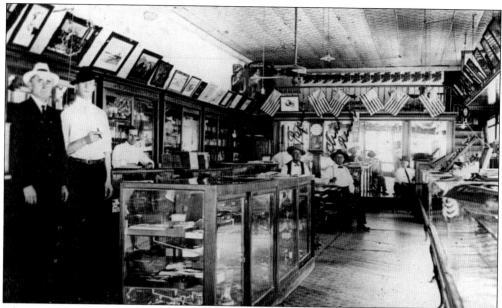

John Birdwell had a friendly rivalry with W. R. Cole and H. Clay Reid. His intentions were to always one-up the gentlemen. John would sometimes enhance the situation by secretly putting Limburger cheese in their hatbands and waiting for the results. John (seated on left) and Clay Reid (seated to John's right) are pictured at Wards Drug store located on the northwest corner of Second and Main Streets.

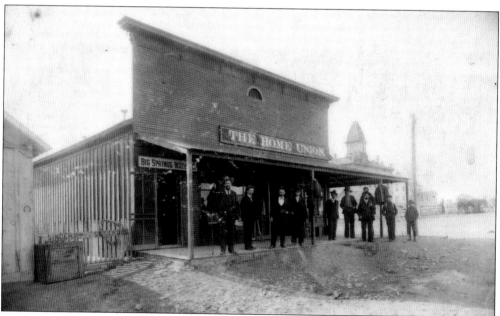

Brothers C. L. and A. D. Alderman opened the first water office in the Home Union Store. The building faced north at the corner of Main and Third Streets. From the onset, there were service interruptions, and during a Commissioners Court meeting it was decided to deduct $25 from the payment to the company, noting that it had failed to furnish a sufficient supply of water for the trough at Third and Main Streets.

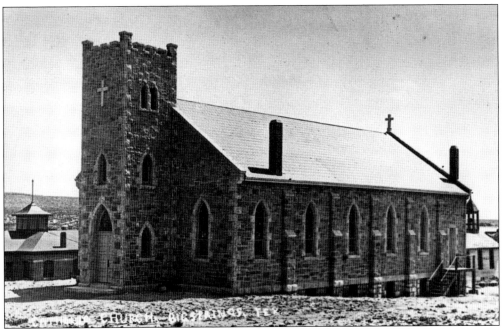

Mrs. George Bauer donated land at 705 North Main Street for a new Catholic church. In 1910, the first cornerstone was laid when the parents of Thomas Fortune of Chicago gave $2,000 in memory of their son. Native limestone was taken from local ranches and used. J. M. Morgan, stonemason, supervised the construction. The church was named St. Thomas Catholic Church.

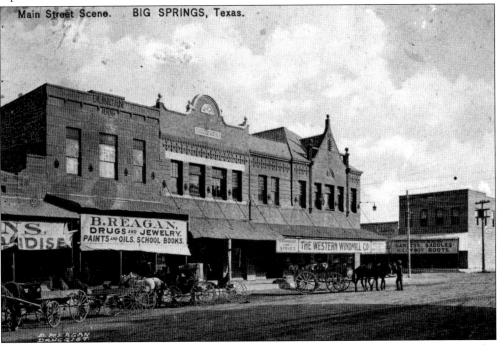

J. D. Bacon established the Bacon Drug Company. It was later acquired by Dr. D. W. McIntyre who passed it to Bascum Reagan. The drugstore included a varied line, including house paint as well as patent medicines. This 1910 postcard shows the east side of the 200 block of Main Street.

Shown are, from left to right, Olive Gentry, Bernard Fisher, and Ethel Nall. Fisher arrived in Big Spring with his parents, William and Nettie Fisher, in 1881. The J&W Fisher Store was well known and respected throughout the community. "There were no finer men," said his employees and customers alike. (Fisher Collection.)

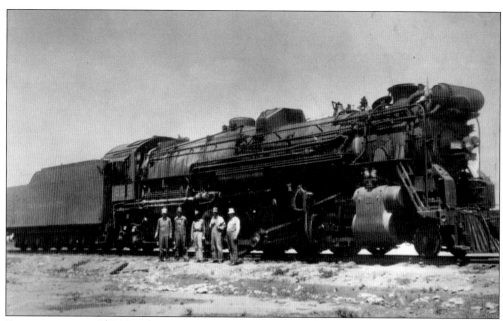

Engineers received $3.90 to $4.00 per 100 miles and firemen $1.90 to $2.00. They worked to stoke wood or coal, keeping the fires burning enough to produce ample steam pressure. The road workers were paid $50 a month plus house, fuel, and water for the section foremen. Laborers received $1 per day, minus 50¢ for board when they required feeding.

Olive Ruth Bird sits on the curb by the Potton house in 1907. The structure was built in 1901 by Joseph Potton to use as a retirement home and was being rented by R. L. Price. Olive Ruth and her mother and father, Maddie Mann Reagan Bird and Walter Bird, lived across from the Potton home on Gregg Street.

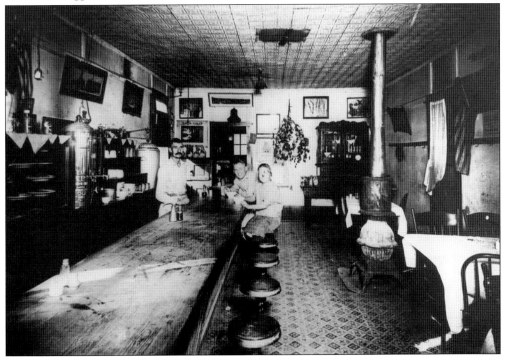

In 1917, the Hockerston Restaurant was located at 201 East Second Street. George Hockerston is standing behind the counter serving two unidentified customers. (Bolding Collection.)

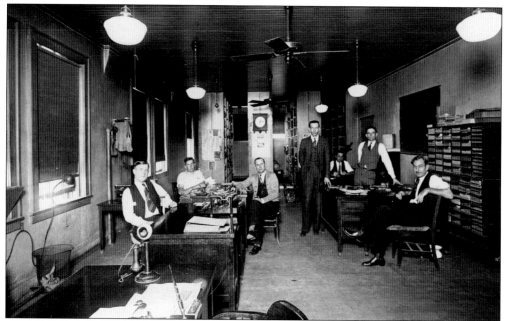

Office personnel at the Texas and Pacific Railway freight office take time to pose for the photographer. Seen here are Doug Sadler (seated, front left), Roy Smith (seated, front right), and H. C. Porter (seated at his desk, back right). Porter's daughter was MGM actress Jean Porter. (Porter Collection.)

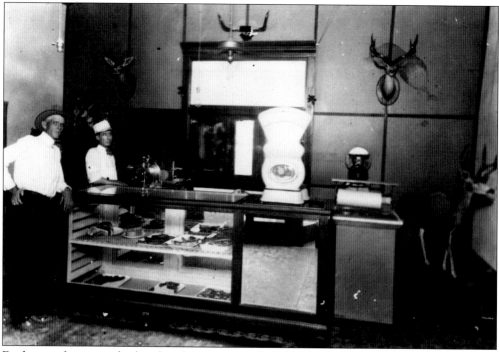

Fresh cuts of meat are displayed in the counter at the John Northington Meat Market located on Main Street next to the State National Bank building. Harold Choate (left) and John Northington are pictured behind the counter. (Choate Collection.)

Five

ROARING TWENTIES
PROSPERITY AND ADVERSITY

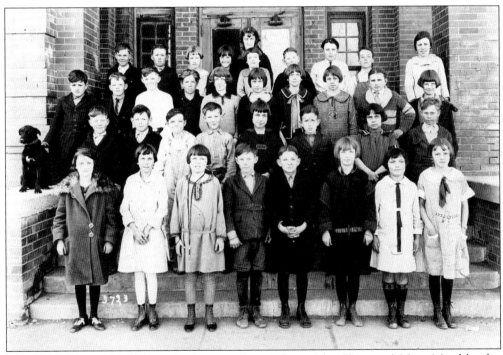

Pictured in this 1924 fifth-grade class are, from left to right, (first row) Nora Marshbanks, unidentified, Vera Davenport, Clyde Thomas, unidentified, Mary Dubberly, Cara Ashley, and Zillah Mae Ford; (second row) four unidentified, Mary Wilke, James Cross, and two unidentified; (third row) unidentified, Raleigh Mims, Bill Flowers, two unidentified, Alma Crews, Loretta Jenkins, and five unidentified; (fourth row) four unidentified, Pauline Melton Duff, Kenneth Shultz, and three unidentified. In the center at the top is Rena Mae Hale, the teacher.

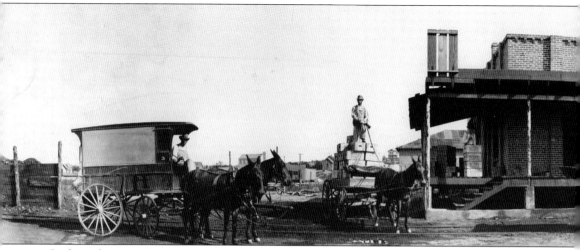

In the early 1900s, Big Spring Ice and Manufacturing Company was located on the north side of the railroad tracks. Ice wagons delivered ice throughout Big Spring. Customers would place a card in their

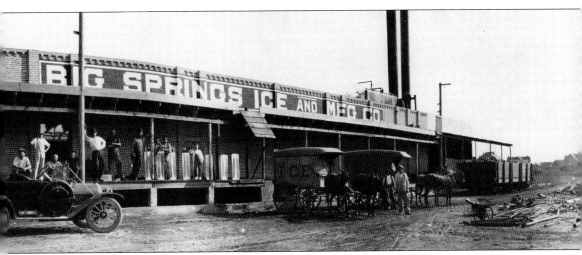

window to indicate how much ice they would like delivered. Ben Boydstun is pictured behind the boxes on the left side of the loading dock. The Bauer house can be seen on the left side in the distance.

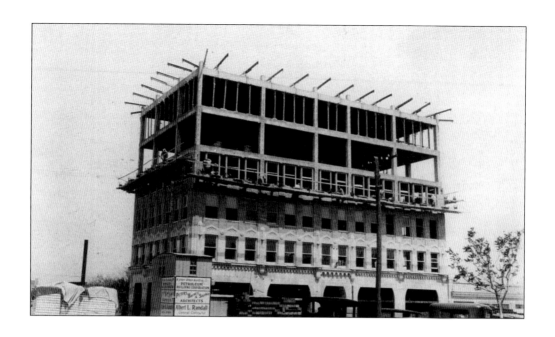

The oil boom of 1926 made the locally constructed $150,000 Petroleum Building possible. With its completion in 1928, it quickly became the headquarters for oil companies, businessmen, and industrialists.

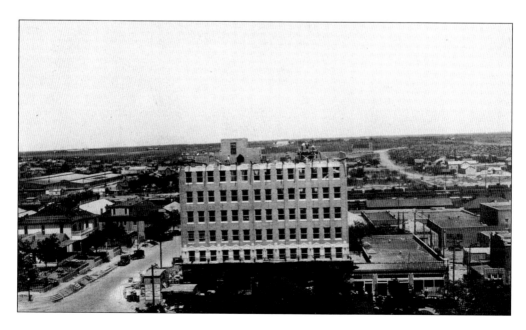

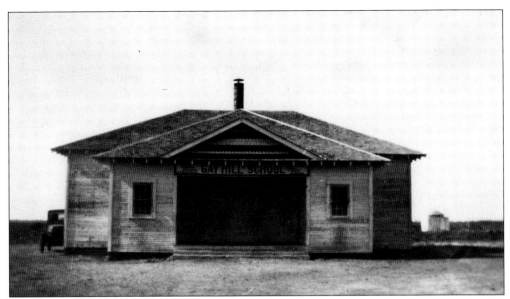

In 1925, Gayhill School was housed in a two-room building with two teachers and 22 students. The school was located 18 miles north of Big Spring. In 1932, the average yearly salary for a teacher was $904.

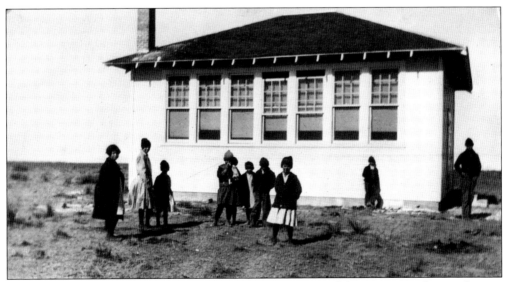

In 1923, L. E. and Mary Helen Lomax moved to this district, and the community became known as Lomax. A school was opened in 1925 with Lillie Mae Hayden (granddaughter of Joseph Potton) as the teacher. (Hayden Collection.)

The Fiveash family lived in this shotgun house. It was called "shotgun" because the houses shot up extremely fast during the discovery of oil. The first producing oil well in Howard County was made by Fred Hyer, "an old-time wildcatter," said Joe Pickle, who found oil in 1925 at 1,508 feet on the Howard and Glasscock County line. (Fiveash Collection.)

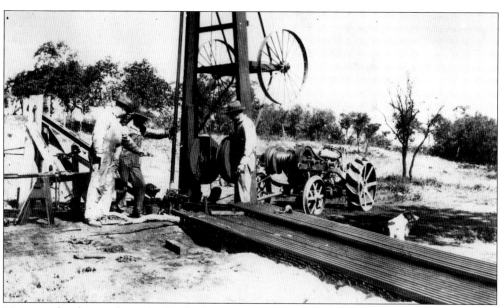

Men were hard at work on the Starky Lease, a rotary on Sun Oil Company, in June 1922. The development and economy of Howard County changed rapidly and dramatically in the 1920s with the discovery of oil. There were men who had a strong will and endurance. Work was hard, while wrestling, digging, pulling, and pumping their livelihood from under the rock soil of West Texas. (Bartlett Collection.)

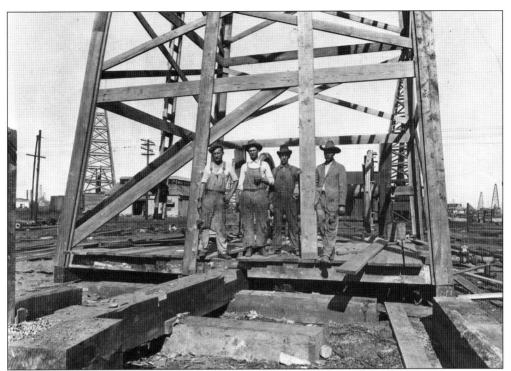

The lure of black gold brought sudden growth to Howard County. Jim Boykin (second from left) and his crew of rig builders are constructing a cable tool rig near Big Spring during the 1920s. Boykin was a rig-building contractor in most every oil field in West Texas and New Mexico. (Boykin Collection.)

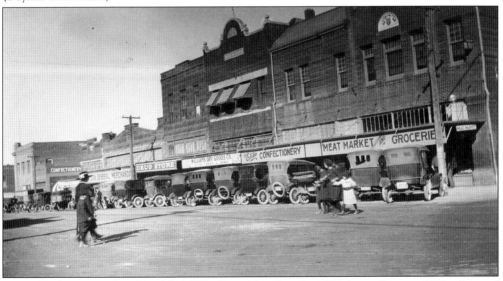

Henry Ford mass-produced his Model T, selling 15 million by 1927. According to a 1921 edition of the *Big Spring Herald*, "A horse that was hitched to a wagon performed a run-away stunt down Main Street and onto East Second. She was caught before the wagon overturned. It is seldom we witness a runaway horses downtown as the automobile has tended to crowd the horses almost entirely off the streets." This photograph was taken facing west on the 200 block of Main Street.

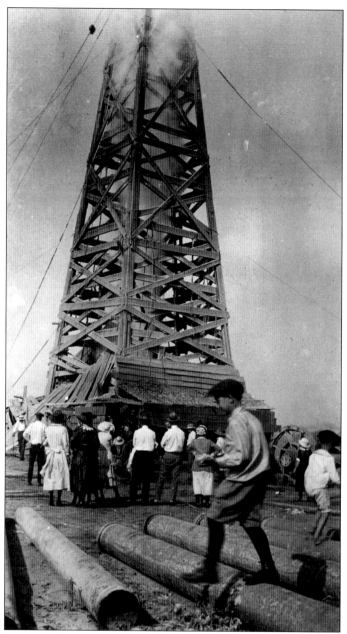

S. E. J. Cox, a flamboyant promoter, infected the town and county with an incurable dose of oil fever. He moved into this area to drill eight holes in virtually every direction from town, with one of them hitting oil. Cox had promoted his company from nothing to a $40-million empire before launching his General Oil Company. On July 20, 1920, crews on General Oil Company's L. S. McDowell lease, encountered oil around 2,650 feet. Cox inspired a huge celebration that swelled the population of 3,500 to over 10,000 for the occasion. Cox told the crowd that had gathered, "While flying into Big Spring, I saw the biggest rainbow I ever saw in my life, with one end touching the ground at Big Spring, Texas. Now we have really found the pot of liquid gold at the end of the rainbow!" The crowd cheered. Although he sold millions of dollars of stock on the strength of the strike, the well never produced commercially.

In a 1921 edition of *Big Spring Herald*, it was announced that Big Spring would again be the division point for the Texas and Pacific Railway mail service. Mail cars line up at 200 Main Street ready to deliver their parcels. Lewis Mauldin was driving the automobile in the center with USM on the front. He took the mail from Big Spring on a route to Lamesa. (Wasson Collection.)

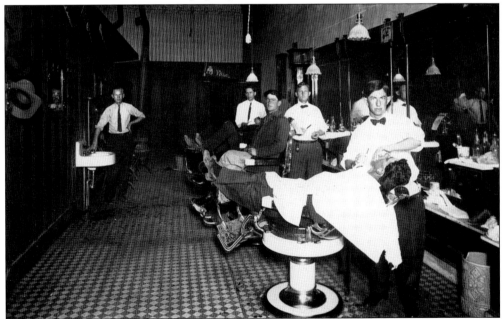

Leslie Thomas (brother to Clyde Sr.) operated the Railroad Barber Shop located on the corner of First and Main Streets.

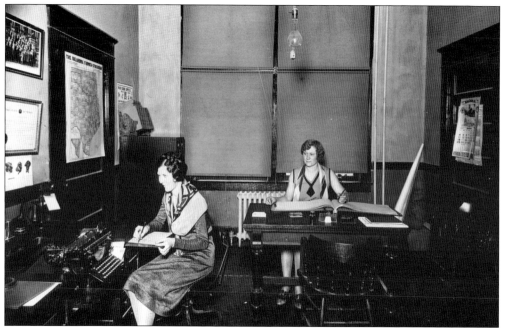

Pauline Cantrell (seated at right) served as Howard County School superintendent from 1928 to 1934. Her assistant was Helen Hayden (left), daughter of Mary and Henry Hayden and granddaughter of Joseph and Mary Potton. The office of school superintendent was abolished in a 1967 legislature. (Acuff Collection.)

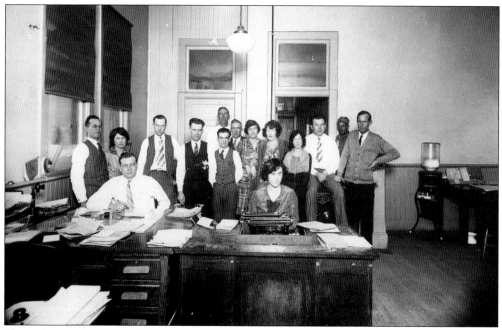

Shown here is the T&P Railway superintendent office in 1920. Seated from left to right are Frank Conder, chief clerk, and Lillian Brunner, stenographer. Standing are Swan Jones, Fannie Russell, John Suttle, O. E. Cater, George Owens, unidentified, B. C. Cole, Katherine Homan, Muriel Alexander, unidentified, Louis Pistole, unidentified, and C. H. Vick. (Russell Collection.)

Six

THE 1930S
A TIME TO REAP, A TIME TO SOW

Frank House worked as a deputy under Sheriff W. W. Satterwhite. House became sheriff upon the sudden death of Satterwhite in 1925. His four-year term was occupied with catching criminals including a group of three young men ages 17–20, who stole 30 turkeys in Dawson County in November 1925.

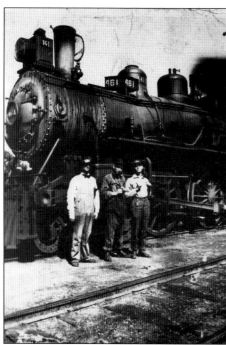

T&P crewmen kept their wives busy washing their overalls and work clothes between trips. Some of the passengers couldn't get used to the idea that soot from the engines' furnaces would infiltrate into the passenger cars, blackening white shirts, cuffs, and collars. Johnny Swindell is pictured in the middle. (Swindell Collection.)

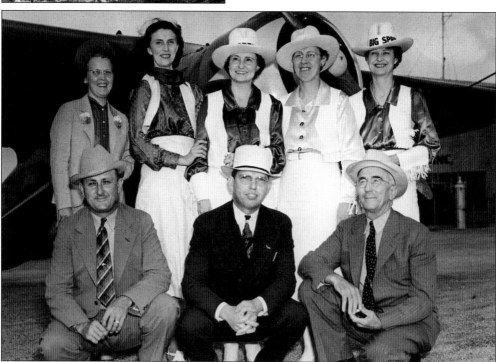

During the 1930s, the chamber of commerce sponsored Big Spring's own Goodwill Singers. The following are, from left to right, (first row) Sheriff Jess Slaughter, Dr. P. W. Malone, and Jimmie Greene; (second row) Mrs. P. W. Malone, pianist Ann Houser, and singers Mrs. Willard Read, Ruby Bell, and Alma Blount. They immediately flew to Fort Worth where they were interviewed and sang on WBAP, touting the appeals of visiting Big Spring.

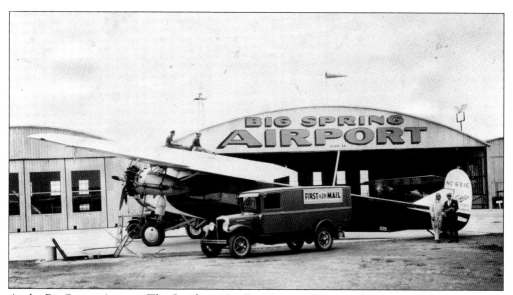

At the Big Spring Airport, The Southern Air Fast Express Company began airmail service in Big Spring on October 13, 1930. A total of 188 pounds containing 15,472 pieces of mail was collected the first day. Owned by oilman Earle Halliburton of Oklahoma, SAFE was to become part of American Airways, which in turn became a part of American Airlines. (Dawson Collection.)

Lester Fisher proudly stands beside his new coupe purchased after his return from World War I. Lester was born in 1881 to William and Nettie Fisher. The couple was involved in a scandalous divorce in 1883, and shortly afterward, William married Anna Kaufman, adding two more children, Albert and Zadee, to the family.

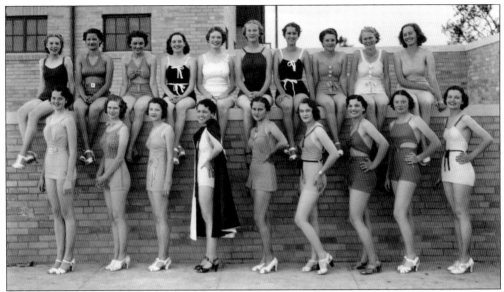

A beauty contest was held in 1936 at the newly completed Municipal Natatorium. Melba Wilson (center with cape) was crowned the winner. The following are, from left to right, (first row) Edith Crodell, Justine Dow, Carnelia Douglass, Melba Wilson, Minnie Bell Williamson, Rozelle Stephens, unidentified, Wanda McSwain, and Charlene Fallon; (second row) Mary Ruth Deltz, Ruth Burnam, unidentified, Mamie Wilson, Mary Louise Wood, unidentified, Mary Alice McNew, Bobbie Taylor, Nell Ro McCrary, and J. Edwards Creighton. (Bradshaw Collection.)

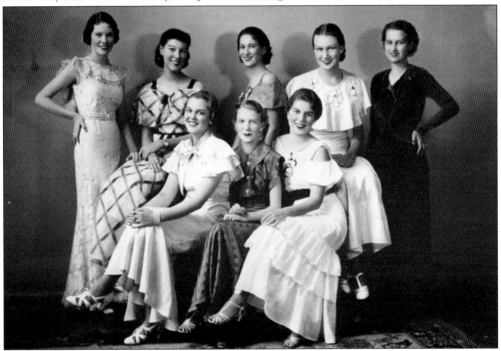

In April 1934, Big Spring debutants were Mary Louise Inkman, Nina Rose Webb, Nancy Philips, Mary Louise Wood, Wynell Woodall, Miss Kuykendall, Doris Cunningham, and Miss McNew. (Bradshaw Collection.)

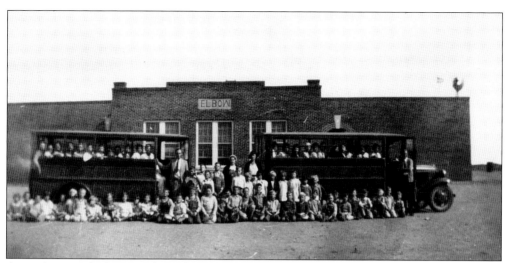

A winding creek that ran through Elbow gave the community and schools their name. The name was chosen for the area because it stood at the bend, or elbow, of the creek. In 1910, this school building was constructed three quarters of a mile from the original one-room building constructed in 1904. The 1910 brick building has been added on to several times and is now a part of the Forsan Independent School District. (Acuff Collection.)

The urgent need for natural gas in Big Spring was met when a 15-mile-6-inch supply line was installed by the city from the Howard-Glasscock oil field in 1929. The Empire Southern Gas Company purchased the struggling gas system in 1931. Pictured are, from left to right, two unidentified, Pat Kenney (manager), Charles Landers (engineer), unidentified, Roy Green, Lesley Clawson, Tony Ledbetter, Lloyd Brooks, and Hubert Clawson.

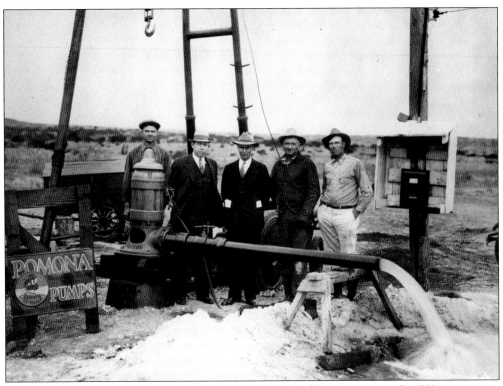

The city water well pumps were only pumping water at 60 gallons per minute. In 1932, new pumps were installed that filtered the clay and sandy soil and pumped water at 190 to 220 gallons per minute. Pictured are, from left to right, Roy Hester, E. V. Spence (city manager), J. L. Webb, (city councilman), Ben Lovelace (water superintendent.), and unidentified. (Pickle Collection.)

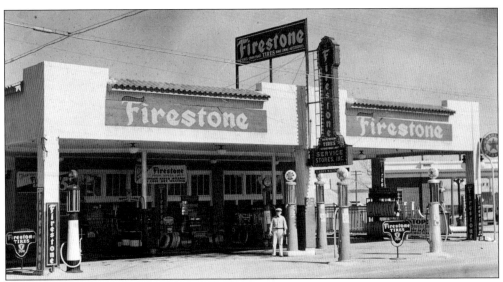

The Firestone Store was located at 507 East Third Street. In 1933, the top of the line Firestone tire sold for $6.20 each, and a Firestone battery sold for $5.40. "The Firestone easy budget plan" offered terms of 50¢ down and 50¢ weekly. (Bradshaw Collection.)

Dr. T. M. Collins (leaning on fountain) opened the Collins Drug Store (shown above), at Second and Runnels Streets, in 1927. The drugstore advertised, "Almost anything a customer might want in the way of cigars, cosmetics, camera supplies, drugs, sundries can be found in the drug store." The prescriptions were located at the back and the soda fountain to the right. The Collins Brother Drug Store merged with Walgreens in 1940, opening a second store at the southeast corner of Third and Main Streets.

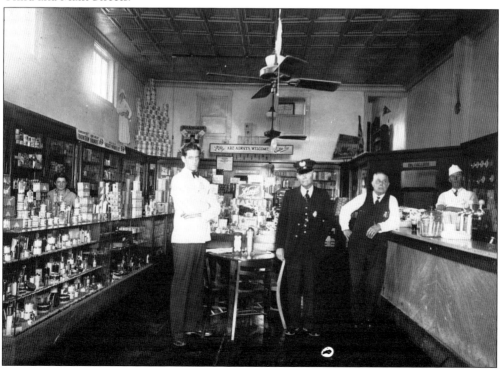

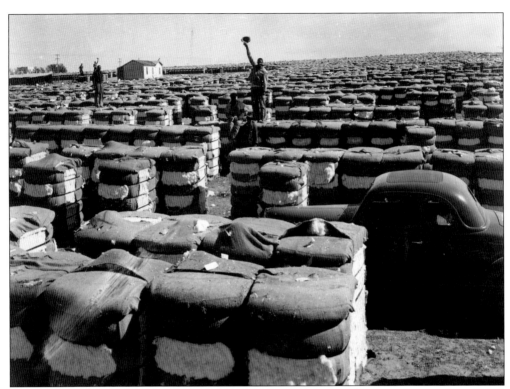

The year 1949 was record-breaking for Howard County farmers, who ginned more than 66,071 bales of cotton. However, in 1952 a terrible drought was the cause of a total production of only 1,200 bales for the county. (Pickle Collection.)

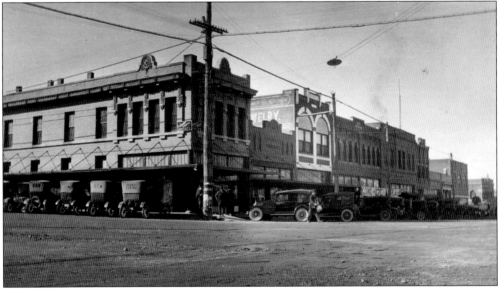

Downtown Big Spring streets were first paved in the late 1920s. By 1931, property owners made requests to the county commissioners for further paving of residential areas. The cost of paving 15 blocks would cost $65,000. The city agreed to pay one-fourth of the cost, while the property owner agreed to pay the remaining three-fourths. (Bradshaw Collection.)

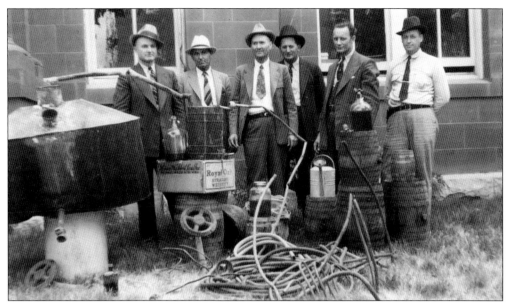

In 1932, the Texas Liquor Board stands in front of an illegal still that was confiscated and on display in front of the courthouse. Prohibition banned the sale, manufacturing, or transportation of alcohol from 1920 to 1933; however, local saloons were closed, and alcohol was made illegal in 1906. Prohibition became increasingly unpopular during the Great Depression, and in 1933, Pres. Franklin Roosevelt revised the law. On midnight, September 15, 1933, twenty-seven firms and retailers were signed up to sell beer in Big Spring.

By 1930, gas prices were 10¢ a gallon, and the average automobile cost $640. In 1936, T. B. Fulkerson (jobber, left) and Lloyd Thompson (truck driver) are pictured by Cosden gas trucks. Gas was transported from the refinery to Cosden gas stations in the area.

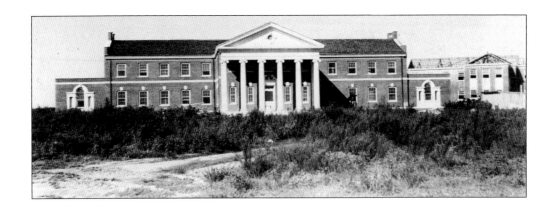

The Big Spring State Hospital, consisting of eight buildings, was constructed in 1938 and officially opened June 1939. The site of the hospital was selected 2 miles northwest of the city and consisted of 577 acres. The hospital housed 402 patients during the first year of operation and in the 1940s operated a dairy, a hog unit, a cotton farm, and a training program for work mules.

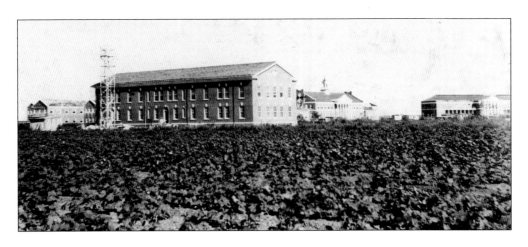

The First National Bank and the West Texas National Bank officially merged on the closing day of Saturday, February 10, 1934. Pictured are bank examiner Robert Piner, president R. L. Price, Harry Hurt, B. Reagan, L. S. McDowell, Ellis Douthit, Iva Thurmond, and Dora Roberts. (Courtesy Wells Fargo Bank.)

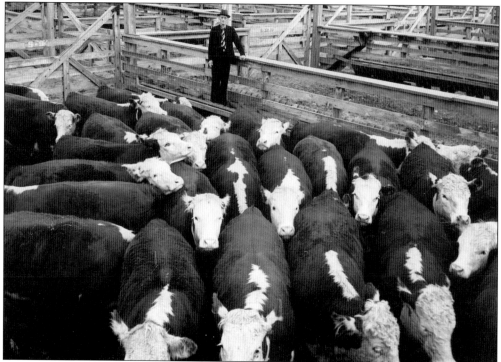

I. B. Cauble oversees his herd at the Fort Worth Stockyards. Cauble was one of the original organizers of the Texas Hereford Breeders Association. He took great pride in breeding Anxiety Fourth Herefords. A true devotee to the Democratic Party, he once threatened to liquidate his herd "if the Republicans get in." Cauble is shown in the passenger seat, as the family traveled to the Redwood forest (which became Redwood National Park in 1968) in California. (Courtesy Raney-Petty Collection.)

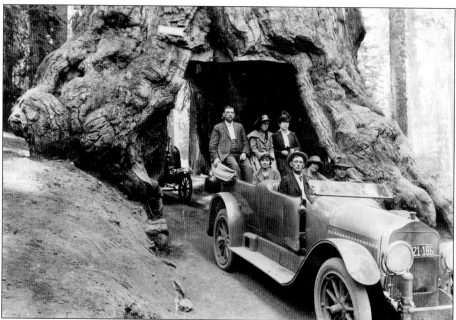

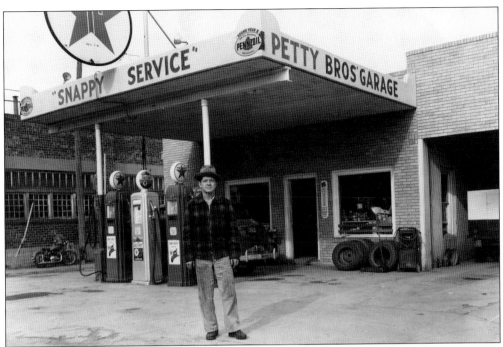

On May 13, 1924, brothers B. F. and Hershel Petty opened the Texaco Snappy Service Station at 213 East Third Street. The station was located directly across from the Settles Hotel and serviced customers for over 43 years before closing. This brick building was constructed in 1943 after the first building burned to the ground. Both brothers claimed to be in excellent health and said they never missed a day of work due to illness. (Courtesy Raney-Petty Collection.)

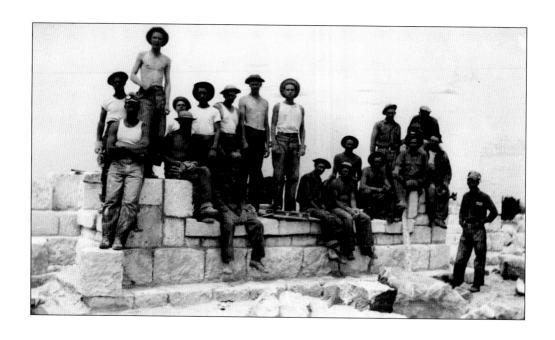

From 1933 to 1942, the Civilian Conservation Corp was a work-relief program for unemployed men. It provided vocational training through the performance of useful work related to conservation and development of natural resources in the United States. The CCC had a camp on the Scenic Mountain, where young men extracted large pieces of limestone from the mountain and then sawed them into large blocks used to construct buildings, pavilions, and retaining walls for use in the parks. (Bradshaw Collection.)

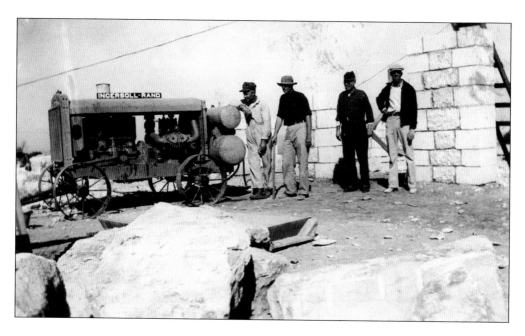

Seven

THE 1940s
A TIME TO SING, A TIME TO DANCE

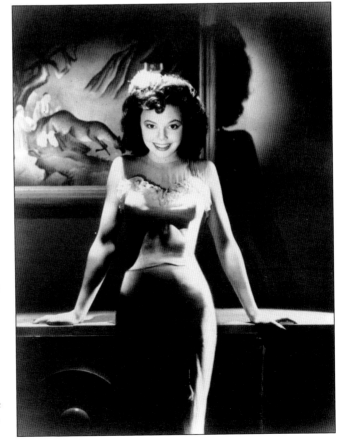

Bennie Jean Porter took dance classes in the Settles Hotel ballroom. As her talent improved, 12-year-old Jean began taking acting classes in Fort Worth by commuting each weekend. She would board the train on Friday evening, arriving in Fort Worth Saturday morning. Her acting coach would pick her up at the train station, and she would spend all day Saturday working on her acting and dancing lessons. At the end of the day, she would catch the train back to Big Spring, arriving Sunday morning in time for church. By 1935, Jean and her mother felt it was time to try their luck in Hollywood. (Porter Collection.)

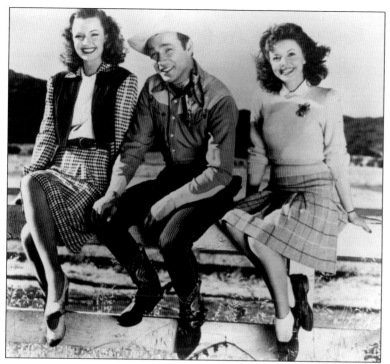

Jean Porter (right) worked with Roy Rogers and Dale Evans in *San Fernando Valley* (1944). Jean said working in Hidden Valley with Rogers and Evans was the greatest thing she could imagine. "The crew would leave before sunrise, arriving at location by 6:00 am. There would be fried eggs and coffee for breakfast at the chuck wagon, and everyone would sit around joking waiting to be called on set." (Porter Collection.)

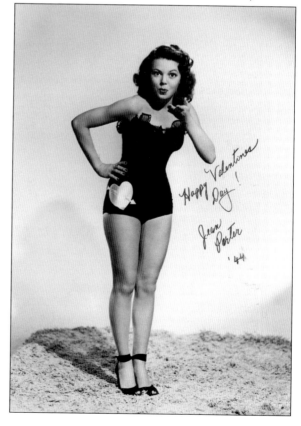

During World War II, Jean Porter entertained the troops and posed for a pinup. She married award-winning director Edward Dmytryk in 1948. The Dmytryks purchased Carole Lombard and Clark Gable's Bel Air estate and raised their four children there; however, Jean always referred to Big Spring as her home. (Porter Collection.)

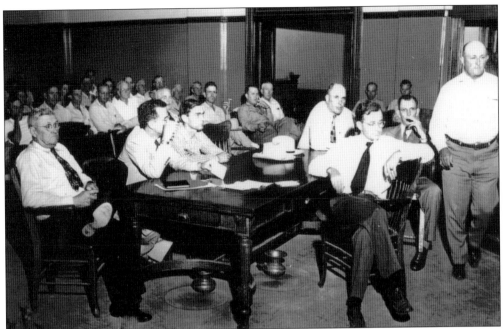

The trial began for "Rodeo Cowboy" Herbert Frizzell. The Rodeo Cowboy was accused of killing two men at the August 4, 1949, Big Spring Rodeo performance. From left to right are defense attorneys Clyde Thomas, George Thomas, Frizzell, Sheriff Bob Wolf, the two prosecuting attorneys, and Jess Slaughter Sr.

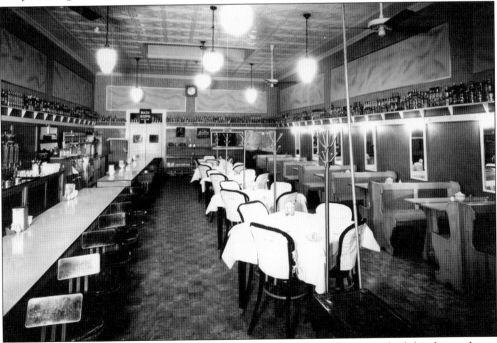

In December 1931, a choice of turkey or chicken dinner was the special of the day and cost customers 50¢ at the Club Café located at 207 East Third Street. Its slogan was, "A Good Place To Eat, We Grow Through Service."

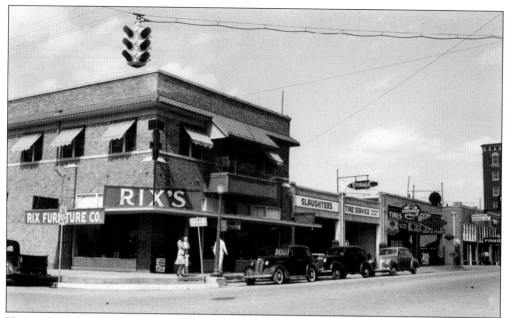

Harvey Rix established Rix Furniture and Undertaking in Big Spring in 1905. His father, B. C. Rix, joined him in business along with his two brothers, Wallace and Jed. After Harvey's passing, his sons Lewis and Ralph took over the operations. In 1941, the Rix store opened a new location at the corner of Gregg and Third Streets. Stores were opened in Lamesa, Tahoka, and Lubbock.

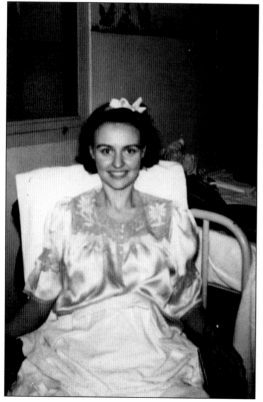

Dorothy Dublin arrived in Big Spring with her parents and sister in 1922 when she was six years old. The 1920s drought forced Dorothy's father, Charlie Dublin, to give up ranching in Coleman, Texas, and work in the oil fields of Big Spring. Dorothy said the family was not readily accepted in the community and mistaken for non-union railroad workers known as "scabs." Once Dorothy recovered from a crippling case of polio, she married her neighbor's (Dora Roberts) grandson Horace Garrett in 1941. (Bradshaw Collection.)

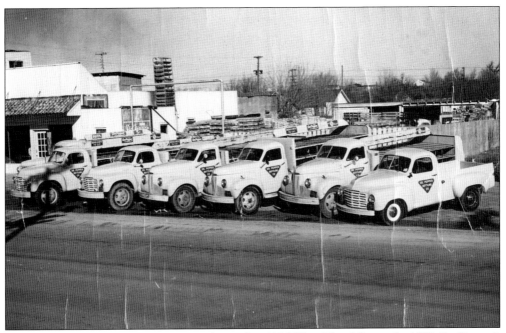

The Dr. Pepper Bottling Company was located at 1006 West Third Street. In 1930, Dr. Pepper's slogan was for customers to remember that the drink was good at "Ten, Two, and Four."

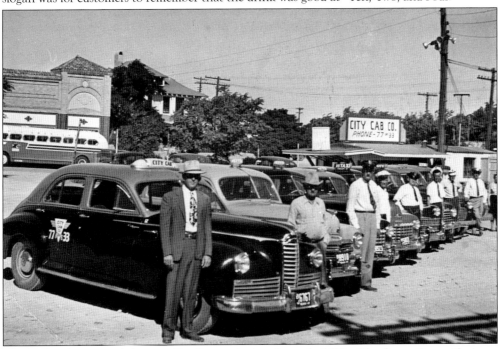

There were four taxicab lines in Big Spring during the early 1940s. The Seven Seven Taxi was located at 312 Runnels Street, Three Three Taxi at 112 Main Street, Gene Taxi at 100 East Third Street, and Yellow Cab located in the lobby of the Crawford Hotel. Pictured are, from left to right, Odie Moore, Henry Moore, Jim Fite, unidentified, W. E. Randell, Elmer Mitchell, Emmett Randell, and Shorty Davis. (Steadman Collection.)

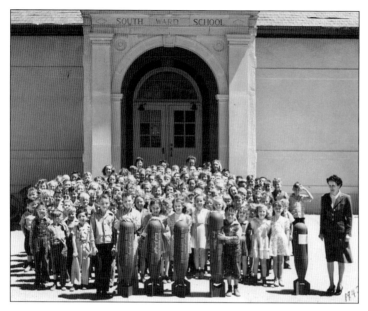

During World War II, Big Spring area schools held paper drives collecting 157,845 pounds of salvaged paper. The paper was converted into containers aiding in the war efforts. Winners of the contest were given a tour of the Big Spring Bombardier School. In 1942, South Ward winners were David Young, Temple Proffitt, Margaret Jackson, and Jerry Wilkins pictured in the front row with teacher Illa Emily Smith. (Wright Collection.)

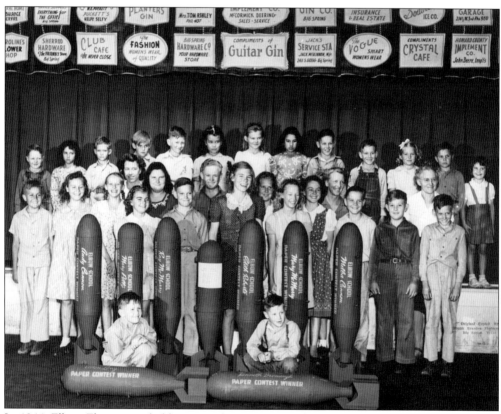

In 1944, Elbow Elementary held a paper drive contest. The winners were Judy Cannon, Mary Petty, Ray McMurry, Edith Roberts, Mary McMurry, Melba Cannon, Alton Long, and Kenneth Bronaugh. (Hill Collection.)

In 1953, Harold Davis, head coach of Howard College baseball and basketball teams, had recruited his players to help raise a metal goal pole on the baseball field. The pole came in contact with a 7,200-volt electric line, killing two students and injuring Davis along with 11 other people. Coaches John Dibrell (left) and Harold Davis coached Howard's single-season football team in 1949.

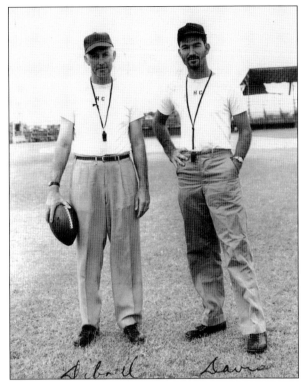

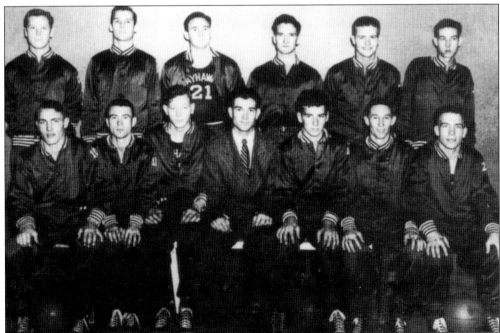

Harold Davis coached Howard College's first basketball team. Team players were, from left to right, (first row) Horace Rankin, Jimmy Peden, G. W. Kennemer, Harold Davis, Gil Burnett, Jimmy Tolbert, and Jack Barron; (second row) Don Clark, Ray Clark, Ladd Smith, Hugh Cochron, Pete Cook, and Ted Pachall.

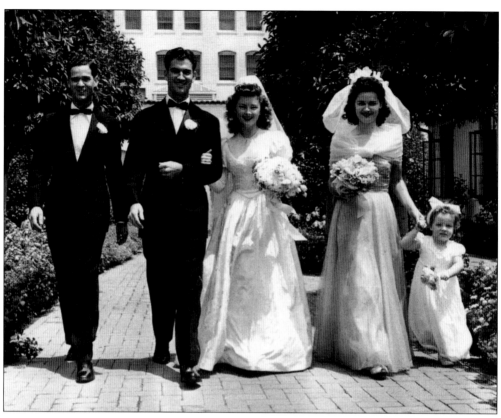

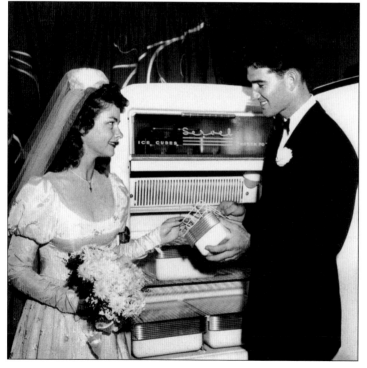

Harold and Janell Davis were married on the "Bride and Groom" radio show on July 14, 1947, in Hollywood, California. The program provided the bride with a beautiful wedding gown, flowers, wedding rings, and a professional photographer. The couple received several gifts including a new Servel refrigerator, platform rocker, and a Max Factor makeup kit for the bride. Lauretta Collins (sister of the groom) was matron of honor, and J. D. Boyd (cousin of the groom) was best man. Harold's three-year-old niece, Jeannie Collins, served as flower girl.

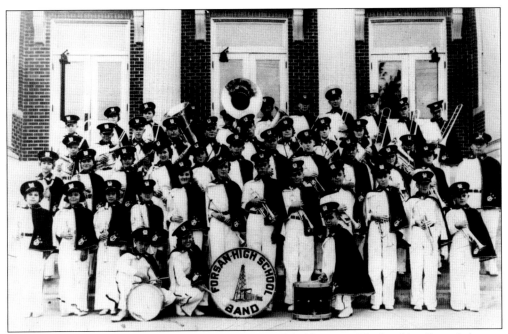

On December 17, 1934, the Forsan High School band, led by M. L. Blackwelder (far right), gave its first public performance in the school gymnasium. The band was composed of 50 pieces and featured two soloists, Wanda Martin (third row, left) and James Underwood (second row, standing fourth from right). (Conger Collection.)

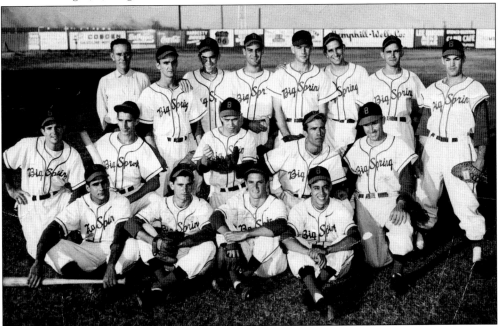

The Big Spring Broncs baseball team was first formed in 1947. The team players included Poncho Ruez, Jimmy Perez, Tony Picot, Ray Vazquez, Orlando Echevarria, Robert Fernandez, Zack Boseh, Ace Escindez, Freddy Rodriquez, Gary Rodriquez, Rolly Vindean, and manager Pat Stasey. (Stephens Collection.)

In 1938, Mary Nell (pictured below) and Anna Bell Edwards (at left), daughters of Marion and Ova Mae Edwards, represented Big Spring in the Midland Rodeo. Both ladies were prizewinners; however, Mary Nell was the winner of the outstanding cutting horse and was awarded a two-horse trailer. The following year, the girls were selected with four others to represent Texas at the Madison Square Garden World Championship Rodeo in New York. They were known as the "Texas Glamour Girls" and were selected by famed manager E. E. Colburn.

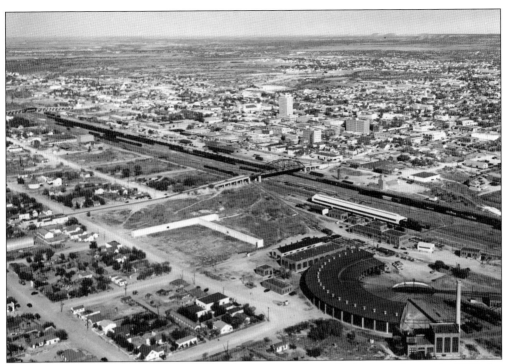

This aerial view shows Big Spring in 1945 from the northwest looking southwest. In 1950, the average price of a home was $3,920 and an average yearly salary was $1,720. The Texas and Pacific roundhouse is shown in the lower right corner. (Pickle Collection.)

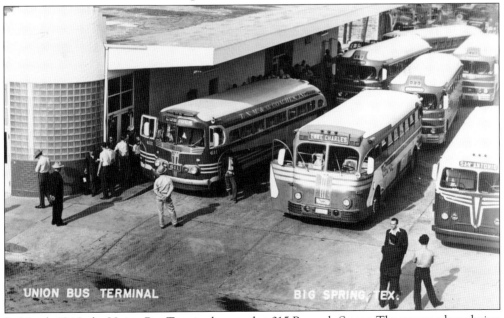

In March 1946, the Union Bus Terminal opened at 315 Runnels Street. The new modern design featured pastel walls with chrome strips. The front was enclosed in glass block, and the building was illuminated with the new fluorescent lighting. Sixty buses arrived at the terminal on a daily basis with 19 various schedules.

In 1927, James L. Johnson Sr. opened his first shop in Forsan, Texas. Southwest Tool and Supply continued to grow and moved to 901 East Second Street in 1948 under the ownership of Johnson and his son James Jr. (pictured on right). The machine shop success was credited to the excellent equipment including huge lathes and drilling machines and large portable and stationary welders. Hoppy Bedell (left) works on the steam trip hammer.

At Southwest Tool and Supply, the large radial arm drill was used to drill holes in thick, heavy gauges of steel. There were 11 employees working for the company in 1948. (Courtesy Johnson family.)

Eight

THE 1950s
LET'S ROCK AND ROLL

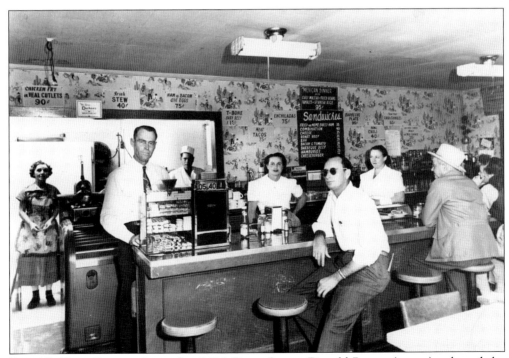

Donald's Drive Inn was located at 2406 Gregg Street. Donald Brown (owner) enlarged the restaurant to include 40 booths in 1948; however, carhops were available to those who did not want to leave their automobile. A hamburger could be purchased for 25¢ when this photograph was taken in 1950.

On the north side of town, the Banks Edition shared a generosity among its neighbors, said Beverly Brown. "One father worked for a bakery and brought the community day old bread and doughnuts. Another worked for a dairy and brought home milk. We'd use mayonnaise jars and shake that sour milk and make a little butter on the top so all the kids had toast and butter." Church of God in Christ No. 1 was located at 1001 First Street Northwest. (Perkins Collection.)

Boy Scout Troop No. 17 members seen here are, from left to right, (first row) Melvin Wrightsil, Floyd Green Jr., Roger Henry, Clarance Hartfield Jr., and Rufus Davis; (second row) Arbin Gene McIntyre, leader Floyd McIntyre, and Nathaniel Green. (Hartfield Collection.)

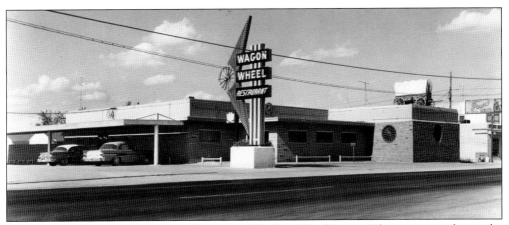

The Wagon Wheel Restaurant was located at 803 East Third Street. The restaurant featured a covered wagon on the roof and a pianist during evening dining. In the 1950s, a lunch special could be purchased for 50¢.

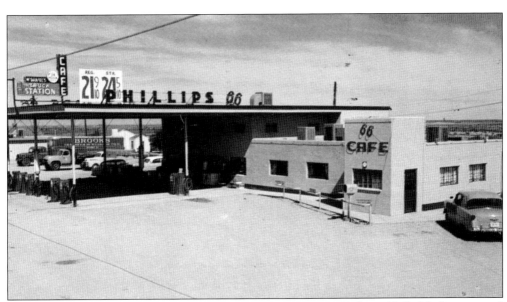

The Phillips 66 Truck Stop was located on West Highway 80. In 1955, Ike and Rilla Medlin managed the terminal and boasted that they offered breakfast 24 hours a day to hungry truck drivers.

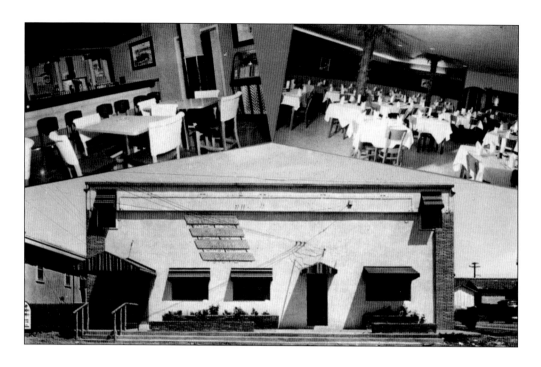

In 1953, Morales Restaurant and Bar moved from West Highway 80 into its new building at 206 Northwest Fourth Street. The Palm Room had a matador motif and featured pictures of lady bullfighter Patricia McCormick. Frank Morales and his wife offered Mexican food, seafood, steaks, and chicken on the menu. In the photograph below, waitresses take a break in between shifts. Seated at far left is Juanice Carter.

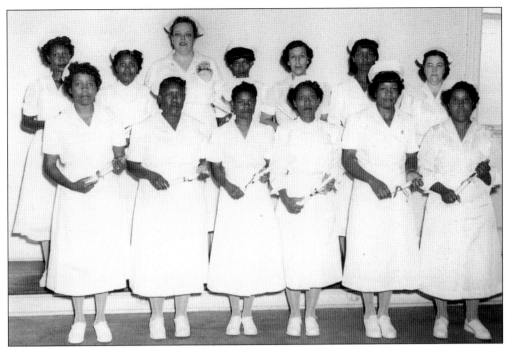

Beverly Martin Brown said, "The courthouse had two water fountains; one marked colored and one marked white. But there wasn't any difference between them. I drank out of both of them, and they were both hot!" This class of nurses graduated from Howard College.

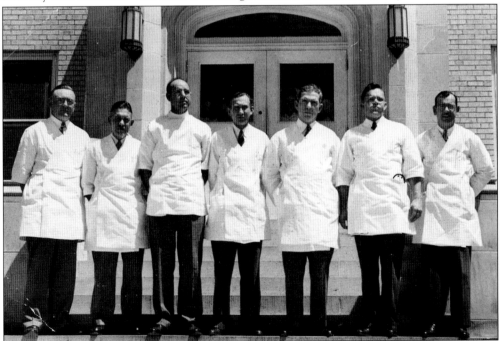

Some of the finest physicians around practiced at Malone and Hogan Hospital at 911 Main Street. Pictured are, from left to right, Drs. John Hogan, ? McIntire, ? Jarrett, J. M. Woodall, P. W. Malone, V. E. Friedwald, and George Peacock. (Hogan Collection.)

Monday, June 27, 1955, marked the opening day of Zacks Dress shop at 204 Main Street. Russian immigrant Jim Zack and his wife, Clara, owned and operated the shop. Clara designed all of the windows, showing a great sense of fashion and style. (Courtesy Susan Zack Lewis.)

Clara Zack (posing on top of Scenic Mountain) graduated at NYU in 1929 before marrying Jim Zack and moving to Big Spring in 1955. She and Jim had one daughter, Susan Zack Lewis. (Courtesy Susan Zack Lewis.)

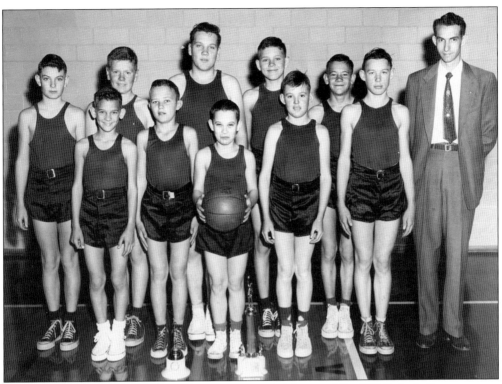

Pictured in the above photograph are the runners-up in Midway and Gay Hill Basketball tournaments in 1954. Pictured from left to right are Esco Hamlin, Mike Wilson, Sonny Anderson, Larry Franklin, Bobby Murphy, Jimmie Lockhart, Joe Bob Clendenin, James Buchanan, Leroy Morton, Ronnie Clanton, and Coach Doyle Fenn. Below, Gay Hill Elementary students participate in a Halloween party. (Fenn Collection.)

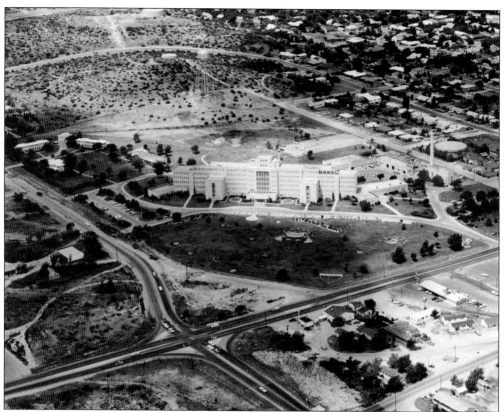

In 1950, the average price for a home was $8,450; however, by 1959, prices rose to $12,400. This aerial view shows the Veterans Medical Center, situated on 31 acres and located in the southern portion of the city. Bordered on the south by Farmers Market 700 and on the east by U.S. Highway 87, it is 1.5 miles south of the downtown business district.

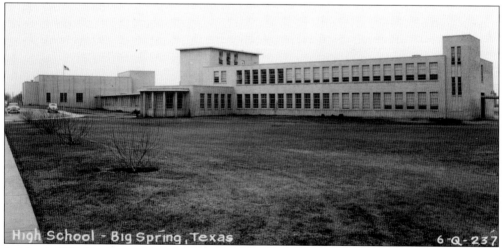

In March 1952, Big Spring High School opened its doors to its new building on Eleventh Place. Enrollment had grown from 411 students in 1904 to 4,793 in 1952. The area of the school district had grown from 25 square miles to 101 square miles. Also in 1952, a court decision by Judge Sullivan provided for Big Spring to be the first school in the state to be integrated by court order.

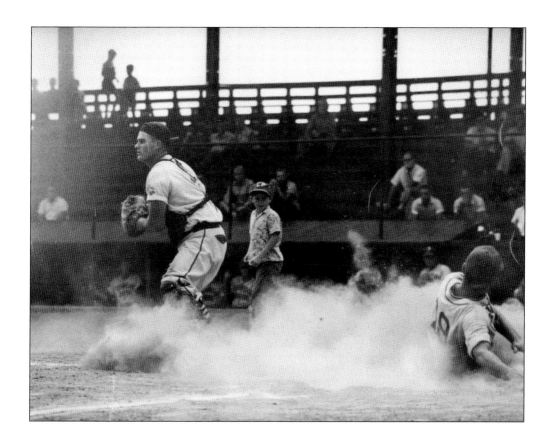

The Cincinnati Reds drafted Robert "Huck" Doe after he graduated from Big Spring High School in 1947. He was traded to the Cleveland Indians before being drafted into the Korean War. Once he returned home, he played for the Cosden Cops Longhorn League. Doe loved the game of baseball so much that he married the love of his life, Emma, on the baseball field's home plate, at Steer Field on June 23, 1955.

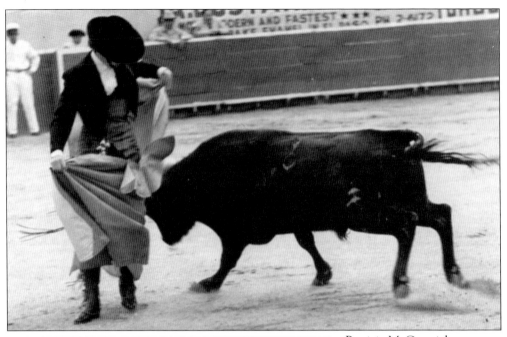

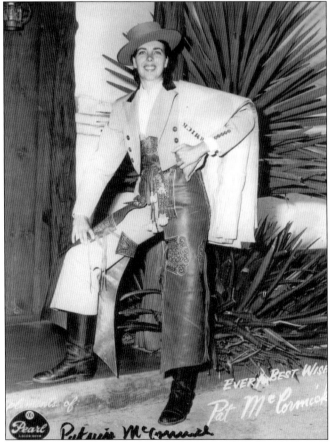

Patricia McCormick graduated from Big Spring High School in 1948 and became one of the world's great bullfighters—one who might have been recognized as the greatest ever had the fighter been born male. McCormick was gored six times during her bullfighter career. She was badly injured in 1954 after being impaled on the horns of a bull. During her recovery, she wrote an autobiography, and in 1963 was featured in an issue of *Sports Illustrated*. (McCormick Collection.)

Twenty-year-old Elvis Presley was starting to become known for "playing a savage guitar and working himself into a frenzy with his blues songs." Presley arrived in Big Spring almost unnoticed and performed at the Municipal Auditorium on April 26, 1955, with Dub Dickerson, Chuck Lee, and Gene Kay. "Lots of clean fun and heaps of music" was advertised. The cost of the show was 50¢. (Taken by Joyce Thomas Flinchbaugh.)

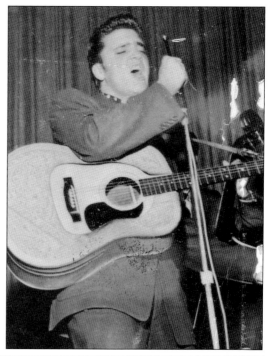

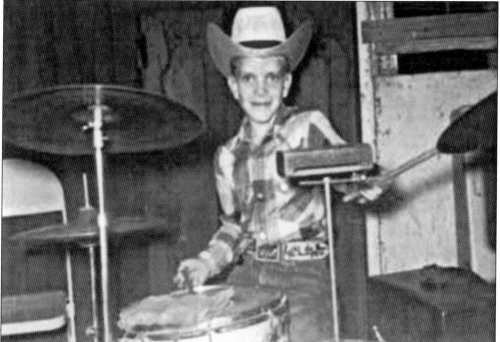

Jody Nix started playing the drums at the age of two; by the time he was eight, he was an official member of his father's band, the West Texas Cowboys. Nix became such a talented performer that he was given the honor of playing at the 1989 Texas State Society Inaugural Ball in Washington for Pres. George W. Bush. Nix and his brother Larry continue to play in the same band with a new name, Texas Cowboys.

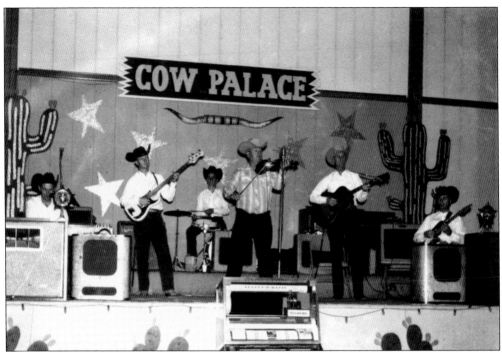

In 1952, brothers Hoyle and Ben Nix and Hoyle's son Larry started a Western Swing band called the West Texas Cowboys. During that same year, Hoyle became friends, and partners on occasion, with country swing legend Bob Wills, the front man for the West Texas Playboys. Hoyle built the Stampede in 1954 on Snyder Highway north of Big Spring. He did not believe in smoking or drinking and expected the same from his band members. When Hoyle and Ben were not playing, they were busy with their farming and ranching operations. Pictured at the Cow Palace are Martin Thomas (steel), Larry Nix (bass), Jody Nix (drums), Hoyle Nix (fiddle), Ben Nix (guitar), and Tommy Horvell (guitar).

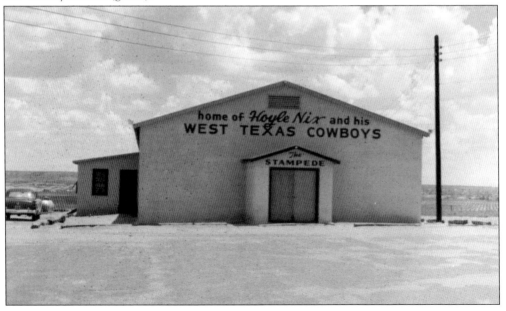

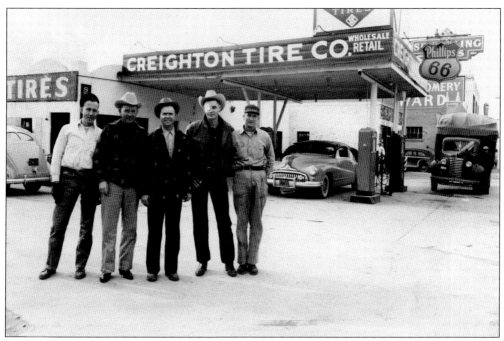

In 1959, Charlie Creighton and Dalton Carr opened Creighton Tire Company and Service Station at 601 Gregg Street. The advertisement that ran in the *Big Spring Herald* was, "Seiberling, your home owned tire headquarters." In 1959, gas prices had risen to 25¢ a gallon.

Kent and Faye Morgan's two children, Emmett Kent, age four, and Katie Bess, age three, were at the old rodeo grounds in 1947. Arlis Ratliff is pictured on the right. The rodeo arena was located on a 20-acre tract between Maple and Birdwell Streets, fronting on Eleventh Place. In 1950, the Big Spring Cowboy Reunion and Rodeo moved to a new home at F.M. 700 and U.S. 80 West.

Drs. Preston, Virgil, and Nell Sanders built Medical Arts Hospital in 1945. Dr. Sanders opened the Medical Arts Vocational School of Nursing before Howard College offered a nursing program. This 1952–1953 class of graduates included, from left to right, (first row) Wanda Arencibia and Opal Rogers; (second row) Jimmie Mae Ellis, Wilma Gibbs, Gracie Williams, Alice Gay, Veda White, and Myrtie Eller.

Bob Smith Lewis's Baylor University roommate encouraged him to move to Big Spring after graduation and work at KBST Radio Station. Lewis became a Texas correspondent for NBC and news director for KHEM radio. His job as correspondent prompted him to produce his own program called "Tumbleweeds." Fans started calling Lewis "Tumbleweed Smith," and his syndicated program was renamed, "The Sounds of Texas." Tumbleweed became nationally known and has won numerous awards including two prestigious Telley Awards.

Ladies from the Cosden Petroleum building celebrate a birthday. From left to right are Beth Key, Jean Yeats, Mamie Roberts, Barbara Stanley, Mike Brooks, Auril Quigley, Pauline Sullivan, Jan Weaver, Mary Ann Taylor, Alma Golick, Juanice Carter, unidentified, Jerry Stevenson, and Lana Wright.

Marj Carpenter won more than 150 writing awards in journalism, in a career that spanned over six decades. In 1962, she helped break the Billie Sol Estes agriculture scandal in Pecos. Her newspaper column, "Riding the Fence," has been a popular source of news for Big Spring residents since the 1970s. One of Marj's closet friends was White House correspondent Sarah McClendon. Marj (left) joined McClendon at the Johnson Ranch in 1966; pictured on the right is Lady Bird Johnson.

www.arcadiapublishing.com

Discover books about the town where you grew up, the cities where your friends and families live, the town where your parents met, or even that retirement spot you've been dreaming about. Our Web site provides history lovers with exclusive deals, advanced notification about new titles, e-mail alerts of author events, and much more.

MADE IN THE USA

Arcadia Publishing, the leading local history publisher in the United States, is committed to making history accessible and meaningful through publishing books that celebrate and preserve the heritage of America's people and places. Consistent with our mission to preserve history on a local level, this book was printed in South Carolina on American-made paper and manufactured entirely in the United States.

This book carries the accredited Forest Stewardship Council (FSC) label and is printed on 100 percent FSC-certified paper. Products carrying the FSC label are independently certified to assure consumers that they come from forests that are managed to meet the social, economic, and ecological needs of present and future generations.

FSC
Mixed Sources
Product group from well-managed forests and other controlled sources

Cert no. SW-COC-001530
www.fsc.org
© 1996 Forest Stewardship Council

Find Your Place in History.